THE BIG
BOOK OF
LOGOS

THE BIG BOOK OF LOGOS

Edited by

DAVID E. CARTER

SUZANNA MW STEPHENS

COLLINS | DESIGN

An Imprint of HarperCollins*Publishers*

HarperCollins books may be purchased for educational, business, or sales promotional use.
For information, please write: Special Markets Department, HarperCollins Publishers,
10 East 53rd Street, New York, NY 10022.

First Edition

First published in 2007 by:
Collins Design
An Imprint of HarperCollins*Publishers*
10. East 53rd Street
New York, NY 10022
Tel: (212) 207-7000
Fax: (212) 207-7654
collinsdesign@harpercollins.com
www.harpercollins.com

Distributed throughout the world by:
HarperCollins*Publishers*
10 East 53rd Street
New York, NY 10022
Fax: (212) 207-7654

Jacket design by: Michael Robinson

Book design by:

Designs on *You!*

Anthony & Suzanna Stephens

Library of Congress Control Number: 2007932766

ISBN: 978-0-06-125574-8

Produced by Crescent Hill Books, Louisville, KY.

Printed in China by Everbest Printing Company.

First Printing, 2007

The Interview: David E. Carter and more

Interviewer: Hello, readers! Here we are at the beachfront condominium of David E. Carter, noted authority on corporate branding, logos, and graphic design. Let's see if he's at home. (*knocking sounds*)

Voice from behind door: Yes?

Interviewer: I'm looking for David E. Carter, noted authority on corporate branding, logos an…

Voice from behind door: He's not here; he's at the beach walking the dog. Or vice versa.

(five minutes later on the beach)

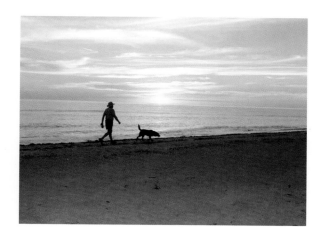

Interviewer: Mr. Carter? Could I ask you a few questions for your latest book?

Carter: Sure. Just don't slow us down. Gotta couple of miles to go.

Interviewer: So exactly how many books have you done so far?

Carter: I dunno exactly. I lost count at 110.

Interviewer: A hundred-and-ten?? You're kidding!!

Carter: Math was never my strong point.

Interviewer: I mean—110 books. That's a lot.

Carter: Well, I started back in 1972.

Interviewer: (*incredulously*) You must have been a small child when you did your first book.

Carter: I was still in my 20s.

Interviewer: The publisher told me that this **Big Book of Logos 5** is very unique.

Carter: That's redundant—"very unique." But yes, this book is unique. It's the first one that has two names on the cover, not just mine.

Interviewer: I noticed that. So who's Suzanna MW Stephens? And why does she have two middle initials?

Carter: "Who IS she?" She's been the book designer for nearly every book I have done since 1996. I think that amounts to about 60 books we have done together. And now her name is on the cover along with mine.

Interviewer: (*baffled*) Why would you want to share the spotlight like that?

Carter: The day is coming when hers will be the only name there. I want to give the book buyers a chance to realize just who she is before that happens.

Interviewer: (*apprehensively*) Have you been… diagnosed…with something…?

Carter: (*laughing*) That's what she asked when I told her. No! I've been producing books for 35 years. A couple of years ago, I moved to Florida after spending my entire career in Kentucky. Now that I'm in Florida full time, I have discovered that I'd rather spend my time walking on the beach and riding my bicycle than producing a new book every two months.

Interviewer: So you're actually planning on turning into a "beach bum?"

Carter: How about a "well-tanned beach bum?"

Interviewer: So, what does this mean for the graphics books you've been doing for 35 years?

Carter: My name will be on the cover—along with Suzanna's—just long enough for the book buyers of the world to know that she's going to produce books with the same level of quality they have come to expect from me. And then, sometime soon, her name will be on the cover all alone.

Interviewer: I can't imagine you doing nothing but working on your tan.

Carter: I'll keep busy. I once did a lot of work in TV. I'm doing some fun TV projects now (*See www. SanibelFilmSchool.com.*) Who knows? Now that I'm in Florida, I may do something like **Golden Girls Gone Wild** (*Carter smiles, tongue firmly in cheek*). But here's Suzanna. You'll probably want to ask her a few questions.

Interviewer: So your name is on the cover of Carter's books now! Same size type as his.

Stephens: No. Not the same size. Dave had wanted to do that, but it wasn't…allowed.

Interviewer: Wasn't allowed?

Stephens: Next question.

Interviewer: Okay. Why do you have two middle initials and what do they stand for?

Stephens: They stand for…

Carter: (*interrupting*) They stand for "My Way." Next question.

Interviewer: Were you surprised when Mr. Carter said that having your name on the cover of this book was just the first step toward his becoming a "well-tanned beach bum?"

Stephens: Surprised? I was shocked! The last time he told me about his long-term plan, he said that after his demise he wanted to be propped in a corner of his office, like **Weekend at Bernie's**, and let his estate collect book royalties forever. My response was "What do you think we're doing now?" He didn't seem to think it was funny, but I laughed enough for both of us.

Interviewer: Will book buyers notice any difference when it's just your name on the cover?

Stephens: They're a very astute group. I'm sure they'll notice the difference between two names and one.

Interviewer: That wasn't exactly what I meant.

Stephens: From a visual standpoint?

Interviewer: Yes.

Stephens: From a visual standpoint then. I've been designing nearly all of Dave's books, though not necessarily the covers, for a long time—eleven years or so.

Interviewer: (*incredulously*) Eleven years! You must have been a small child when you did your first book.

Stephens: As Dave likes to say about our first meeting, "She was in her 30s, but she looked like a 25-year old who'd had a really bad night's sleep."

Interviewer: (*contrite*) Oh.

Stephens: ANYWAY, I'd like to think I'll continue on a professional level that's equivalent to Dave's but now have the opportunity to actually make a decis…

Carter: (*interrupting*) She is a very talented individual. She's a gifted writer as well as designer and I think people who have been buying my books for all these years will quickly realize that the quality of books with her name on the cover will be just as high as the ones I have been producing. Maybe even better. Don't

forget that name—Suzanna MW Stephens.

Stephens: Gosh, Dave, that's very nice. Thanks! If I'd known you thought that highly of me all these years, I would've hit you up for a raise.

Carter: Next question.

1.

2.

3.

4.

5.

6.

7.

1
Design Firm **SkiCreative**
2
Design Firm **WGTE Public Broadcasting**
3 - 6
Design Firm **Graphicat Limited**
7
Design Firm **Twointandem LLC**

1.
Client Eclipse Salon & Day Spa
Designer Chris Sniegowski
2.
Client Aeon Education
Designer Alex Chandler Jr.
3.
Client JC Holdings Limited
Designer Colin Tillyer
4.
Client Mandarin Shipping Limited
Designer Colin Tillyer

5, 6.
Client Noble Group Limited
Designer Colin Tillyer
7.
Client Simplynu™
Designers Sanver Kanidinc,
 Elena Ruano Kanidinc

1.

2.

3.

4.

5.

6.

7.

1 - 4
Design Firm **Beth Singer Design, LLC**
5 - 7
Design Firm **Sightline Marketing**
1.
Client American Israel Public Affairs
 Committee National Summit 2006
Designer Suheun Yu
2.
Client Cable in the Classroom
Designers Chris Hoch, Sucha Snidvongs
3.
Client Partnership for Jewish Life
 and Learning
Designer Sucha Snidvongs
4.
Client TCI
Designers Sucha Snidvongs, Chris Hoch
5.
Client Ocean Atlantic
Designer Emily Wilson

6.
Client BES Capital Partners
Designers Samantha Guerry, Kate Stoddard,
 Anthony Begnoche
7.
Client Intelligence and National
 Security Alliance
Designer Clay Marshall
(opposite)
Design Firm **Alexander Atkins Design, Inc.**
Client Bullis Charter School
Designer Alexander Atkins

AFriend
ASSOCIATION FOR RESPONSIBLE INNER
EASTSIDE NEIGHBORHOOD DEVELOPMENT

1.

2.

3.

4.

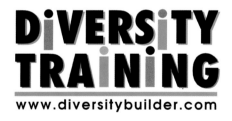

5.

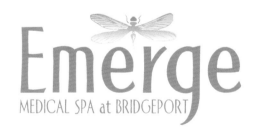

6.

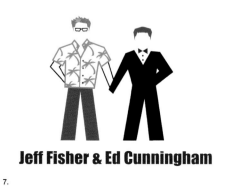

Jeff Fisher & Ed Cunningham

7.

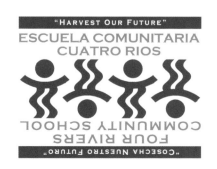

8.

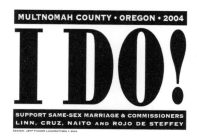

MULTNOMAH COUNTY • OREGON • 2004
I DO!
SUPPORT SAME-SEX MARRIAGE & COMMISSIONERS
LINN, CRUZ, NAITO AND ROJO DE STEFFEY
DESIGN: JEFF FISHER LOGOMOTIVES © 2004

9.

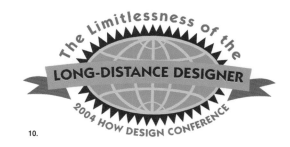

10.

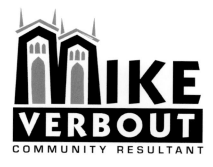

MIKE VERBOUT
COMMUNITY RESULTANT

11.

YOUNG NATIVE WRITERS
ESSAY CONTEST
Holland+Knight
Charitable Foundation, Inc.

12.

NEIGHBORHOOD
SERVICE CENTER

13.

just|out

14.

15.

1 - 15		
Design Firm	**Jeff Fisher LogoMotives**	
1.		
Client	Association for Responsible Inner Eastside Neighborhood Development	
Designer	Jeff Fisher	
2.		
Client	Balaboosta Delicatessen	
Designer	Jeff Fisher	
3.		
Client	Bella Terra Landscape Designs	
Designer	Jeff Fisher	
4.		
Client	Benicia Historical Museum	
Designers	Jeff Fisher, Sue Fisher	
5.		
Client	DiversityBuilder.com	
Designer	Jeff Fisher	
6.		
Client	Emerge Medical Spa at Bridgeport	
Designer	Jeff Fisher	
7.		
Client	Jeff Fisher/Ed Cunningham Wedding	
Designer	Jeff Fisher	

8.		
Client	Four Rivers Community School	
Designer	Jeff Fisher	
9.		
Client	I Do/Same—Sex Marriage Campaign	
Designer	Jeff Fisher	
10.		
Client	Long-Distance Designer Presentation/HOW Design Conference	
Designer	Jeff Fisher	
11.		
Client	Mike Verbout, Community Resultant	
Designer	Jeff Fisher	
12.		
Client	Holland+Knight Charitable Foundation, Inc.	
Designer	Jeff Fisher	
13.		
Client	City of Portland/Office of Neighborhood Involvement	
Designer	Jeff Fisher	
14.		
Client	Just Out Newsmagazine	
Designers	Jeff Fisher, Marty Davis	
15.		
Client	NoBox Design	
Designer	Jeff Fisher	

1.

2.

3.

4.

5.

6.

7.

1 - 7
Design Firm **Jeff Fisher LogoMotives**
1.
Client North Portland Business Association
Designer Jeff Fisher
2.
Client North Portland Pride/
 University Park United
 Methodist Church
Designer Jeff Fisher
3.
Client Our House of Portland
Designer Jeff Fisher
4.
Client The Parenting Alliance
Designer Jeff Fisher
5.
Client Portsmouth Neighborhood
 Association
Designer Jeff Fisher

6.
Client Reed College/Fall Thesis 2004
Designer Jeff Fisher
7.
Client Reed College/Fall Thesis 2005
Designer Jeff Fisher
(opposite)
Design Firm **FutureBrand**
Client Amanda Hoover, Mike Williams
Designer Mike Williams

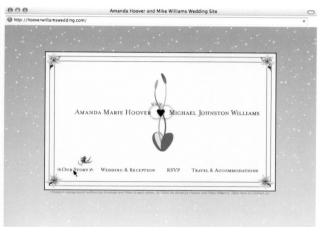

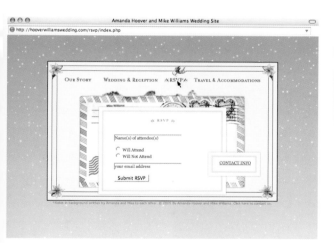

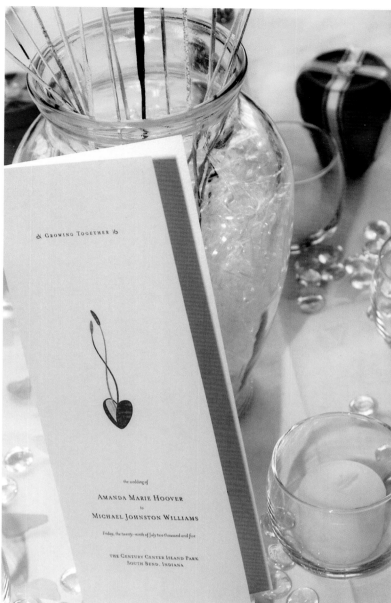

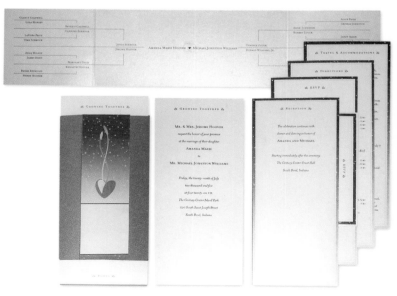

13

1.

2.

3.

4.

5.

6.

Twisted Elegance
INTERACTIVE

7.

1 - 7
Design Firm **Jeff Fisher LogoMotives**
1, 2.
Client Residence XII
Designer Jeff Fisher
3.
Client Holy Trinity Philoptochos
Designer Jeff Fisher
4.
Client Thomas Fallon, Architect
Designer Jeff Fisher
5.
Client George Fox University / Tilikum
 Center for Retreats & Outdoor
 Ministries
Designer Jeff Fisher
6.
Client Building Letters Three
Designer Jeff Fisher

7.
Client Twisted Elegance Interactive
Designer Jeff Fisher
(opposite)
Design Firm **Hornall Anderson**
 Design Works LLC
Client Eos Airlines
Designers Jack Anderson, Mark Popich,
 David Bates, Andrew Wicklund,
 Leo Raymundo, Jacob Carter,
 Yuri Shvets

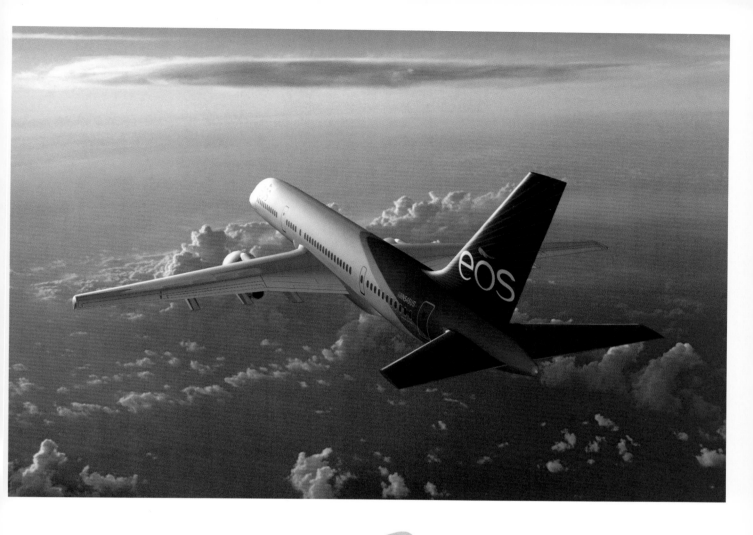

1.

2.

3.

4.

5.

6.

7.

8.

9.

UK
IMO
————
2002

10.

ink!

11.

12.

13.

IGF INTERNATIONAL GUITAR
FOUNDATION & FESTIVALS

14.

15.

1 - 2		
Design Firm	**Jeff Fisher LogoMotives**	
3 - 15		
Design Firm	**Mytton Williams**	
1.		
Client	VanderVeer Center	
Designer	Jeff Fisher	
2.		
Client	St. Johns Window Project	
Designer	Jeff Fisher	
3.		
Client	Withy King Solicitors	
Designers	Bob Mytton, Peter Greenwood	
4.		
Client	Appoint	
Designers	Bob Mytton, Matt Judge	
5.		
Client	Bath Business Women's Association	
Designers	Bob Mytton, Steph Weekes	
6.		
Client	Capita	
Designer	Bob Mytton	
7.		
Client	Commission for Rural Comunities	
Designers	Bob Mytton, Matt Judge	

8.	
Client	Fast Search and Transfer
Designers	Bob Mytton, Rob Duncan
9.	
Client	Outposts
Designer	Bob Mytton
10.	
Client	International Mathematical Olympiad
Designer	Bob Mytton
11.	
Client	Ink Copywriters
Designers	Bob Mytton, Tracey Bowes
12.	
Client	Mann Williams
Designers	Bob Mytton, Rob Duncan
13.	
Client	Nicola Tilling
Designers	Bob Mytton, Gary Martyniak
14.	
Client	International Guitar Foundation and Festivals
Designer	Bob Mytton
15.	
Client	Resolute
Designers	Bob Mytton, Tracey Bowes

1.

2.

3.

4.

5.

6.

7.

1
 Design Firm **Mytton Williams**
2 - 6
 Design Firm **Wood Street, Inc.**
7
 Design Firm **18 Visions Design**

1.
 Client Thermae Bath Spa
 Designers Bob Mytton, Peter Greenwood
2.
 Client Clipper City
 Designer Andrew McClellan
3.
 Client It Is Done Communications
 Designer Andrew McClellan
4.
 Client Radiation Incident Committee
 Designer Andrew McClellan

5.
 Client Rub Wear
 Designer William Rockenbaugh
6.
 Client Aesthetic Imaging
 Designer William Rockenbaugh
7.
 Client Layman Real Estate
 Designer Andrew McClellan
(opposite)
 Design Firm **Kelly Brewster Design**
 Client Burtin Polymer Laboratories
 Designer Kelly Brewster

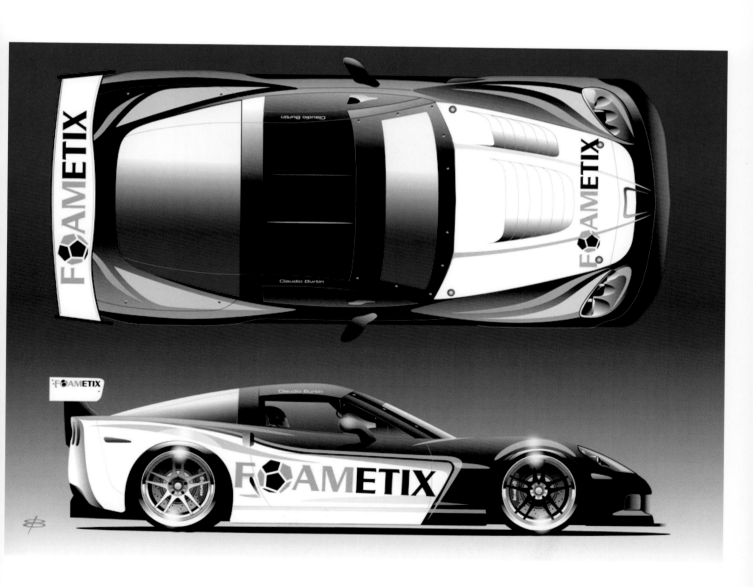

1.

CYPRESS CYPRESS CYPRESS

CYPRESS CYPRESS CYPRESS

2.

3.

4.

5.

6.

FLORIDA'S FORECLOSURE ALTERNATIVE LLC
PROTECTING YOUR INVESTMENT IN YOUR HOME

7.

1 - 7

Design Firm **Gouthier Design:**
a brand collective

1.
Client Community Christian School
Designers Gouthier Design Creative Team

2.
Client Cypress Interior Design
Designers Gouthier Design Creative Team

3.
Client Desirability
Designers Gouthier Design Creative Team

4.
Client Pickwick Challenge
Designers Gouthier Design Creative Team

5.
Client Erin London
Designers Gouthier Design Creative Team

6.
Client Florida's Foreclosure Alternative, LLC
Designers Gouthier Design Creative Team

7.
Client Fellowship Productions
Designers Gouthier Design Creative Team

(opposite)
Design Firm **Hornall Anderson**
Design Works LLC
Client Weyerhaeuser Corporation
Designers Jack Anderson, James Tee,
 Andrew Wicklund, Elmer dela Cruz,
 Holly Craven, Jay Hilburn,
 Hayden Schoen, Belinda Bowling,
 Yuri Shvets, Michael Connors

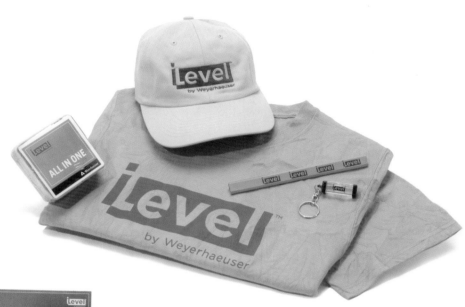

1.

APPLIED
DIALING

2.

BACA
SIGALA
& ASSOCIATES

3.

calvin
l e e
design

4.

5.

6.

7.

8.

9.

10.

11.

12.

13.

14.

15.

1.

Crescent Court

2.

JOHN LAING URBAN
Style. At the center of life.

3.

PORTOLA
SPRINGS™

4.

5.

6.

7.

1-5
Design Firm **Greenhaus**
6, 7
Design Firm **Design Group West**

1.
Client — Amore Vellano Homes
Designers — Tracy Sabin, Jerry Sisti, S. Michael Grace, Craig Fuller

2.
Client — Crescent Court Homes
Designers — Tracy Sabin, Jason Nunez, Martina Austin, Craig Fuller

3.
Client — John Laing Urban Homes
Designers — Tracy Sabin, Christina Blankenship

4.
Client — Portola Springs Homes
Designers — Tracy Sabin, Don Stephenson, Craig Fuller

5.
Client — Project Nate
Designers — Tracy Sabin, Michelle Prescott, Craig Fuller

6.
Client — University of San Diego
Designers — Tracy Sabin, Jim Naegeli

7.
Client — University of San Diego Toreros
Designers — Tracy Sabin, Jim Naegeli
(opposite)
Design Firm **It's a Go!**
Client — Nasrec Arena
Designers — Sean Fandam, Glenda Venn

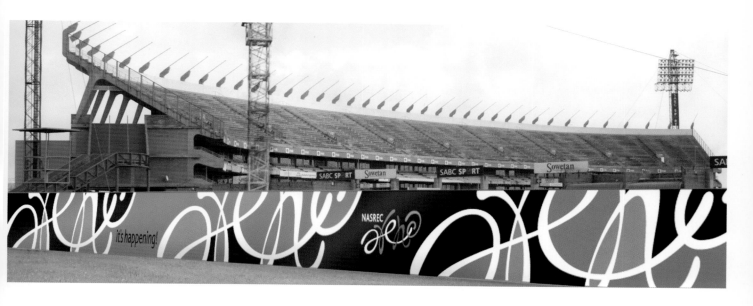

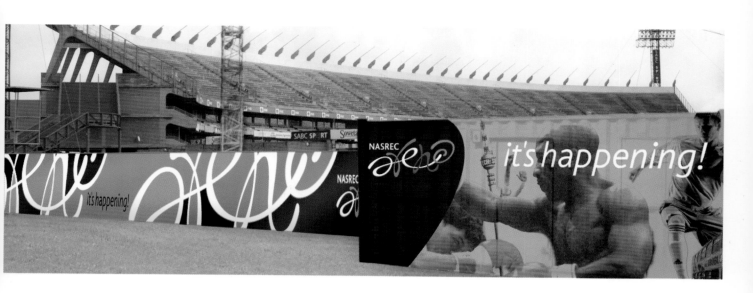

1.

2.

3.

4.

5.

6.

7.

1
 Design Firm **Type G Design**
2 - 7
 Design Firm **Sabingrafik, Inc.**
1.
 Client Bird Rock Entertainment
 Designers Tracy Sabin, Mike Nelson
2.
 Client Blue Ridge Lighting
 Designers Tracy Sabin,
 Christopher Todd McPhetridge
3.
 Client Country Critter Rustic
 Home Furnishings
 Designers Tracy Sabin,
 Christopher Todd McPhetridge
4.
 Client K9 Connection
 Designers Tracy Sabin, Nicole Andrews
5.
 Client Luxury Dog Products
 Designers Tracy Sabin, Troy Martz

6.
 Client M5 Productions
 Designers Tracy Sabin, Mike Hinchman
7.
 Client Ojai Pixie Tangerines
 Designers Tracy Sabin, Lisa Brenneis
(opposite)
 Design Firm **Whitney Edwards, LLC**
 Client ACE Mentor Program of America
 Designer Charlene Whitney Edwards

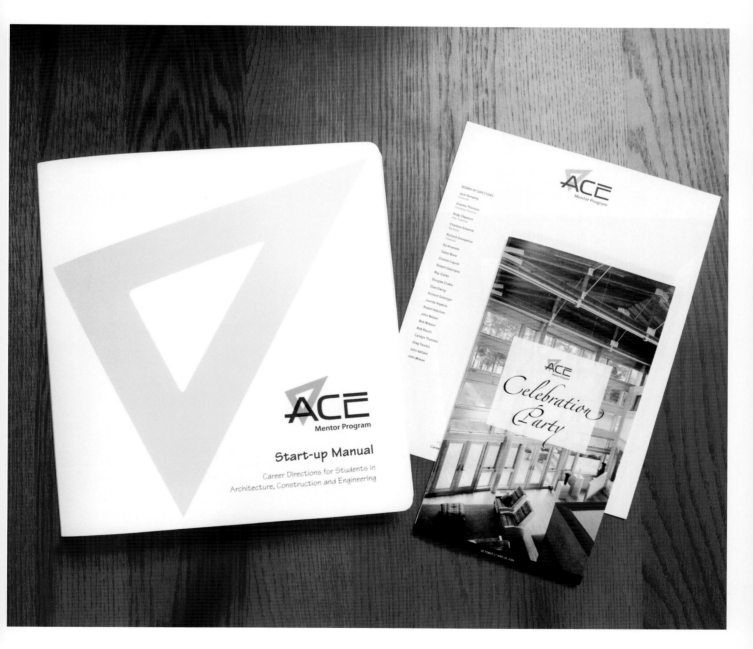

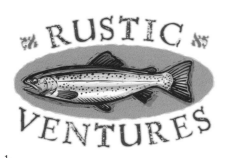

1.

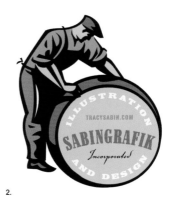

2.

3.

4.

5.

6.

7.

8.

9.

10.

11.

SETTLERS
RIDGE
SUGAR GROVE

12.

Westmark School
DISCOVER YOUR PATH TO SUCCESS

13.

Treasure
State Bank

14.

15.

1 - 15
Design Firm **Sabingrafik, Inc.**
9 - 12
Design Firm **Roni Hicks & Associates**
13
Design Firm **Kokinakes Design**
14
Design Firm **Partners Creative**
15
Design Firm **Meads Durket, Inc.**
1.
Client Rustic Ventures
Designers Tracy Sabin,
 Christopher Todd McPhetridge
2.
Client Sabingrafik, Inc.
Designer Tracy Sabin
3 - 5.
Client Seafarer Baking Company
Designers Tracy Sabin, Bridget Sabin
6.
Client Srimad Bhagavata
 Vidyapitham School
Designers Tracy Sabin, Eero Sabin

7.
Client Weathervanes Unlimited
Designers Tracy Sabin,
 Christopher Todd McPhetridge
8.
Client Trinchero Family Estates
Designers Tracy Sabin, Ken O'Brien
9.
Client Brightwater Ranch Homes
Designers Tracy Sabin, Danny Zaludek
10.
Client Ingham Park Homes
Designers Tracy Sabin, Danny Zaludek
11.
Client La Costa Ridge Homes
Designers Tracy Sabin, Stephen Sharp
12.
Client Settlers Ridge Homes
Designers Tracy Sabin, Danny Zaludek
13.
Client Westmark School
Designers Tracy Sabin, Paul Kokinakes
14.
Client Treasure State Bank
Designers Tracy Sabin, Steve Falen
15.
Client William Lyon Homes
Designers Tracy Sabin, Doug Moore

1.

2.

3.

4.

5.

6.

GARRETT
R A N C H

7.

1, 2
Design Firm **Vitro/Robertson**

3
Design Firm **Markatos Design**

4
Design Firm **NYCA**

5
Design Firm **Fuel Creative**

6
Design Firm **McNulty Creative**

7
Design Firm **Janis Brown & Associates**

1.
Client Yamaha Watercraft Bermuda 2007
Designers Tracy Sabin, Dave Roberts

2.
Client Giving Groves
Designers Tracy Sabin, Mike Brower

3.
Client Bravo Dog Training
Designers Tracy Sabin, Peter Markatos

4.
Client Chileno Bay
Designers Tracy Sabin,
 Lynn Cooper Roswall

5.
Client Cooperage Marina/Condos/Village
Designers Tracy Sabin, Taylor Vandiver

6.
Client StreamHawk Erosion
 Control Solutions
Designers Tracy Sabin, Mary McNulty

7.
Client Garrett Ranch
Designers Tracy Sabin, Janis Brown

(opposite)
Design Firm **Subplot Design Inc.**
Client Vancouver Aquarium
Designers Roy White, Matthew Clark

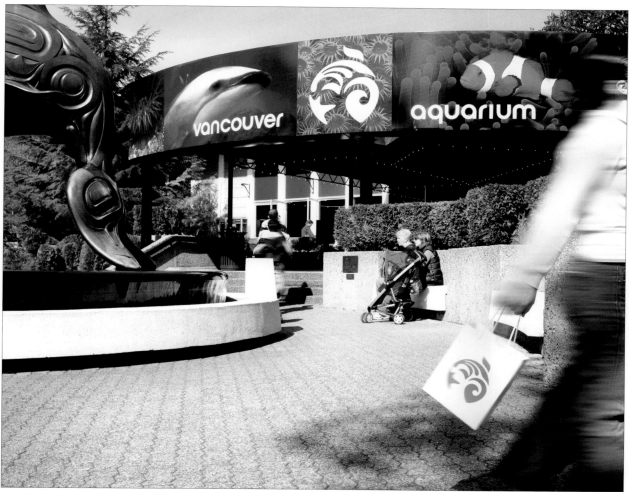

1.

2.

3.

4.

5.

6.

7.

1
Design Firm **Seedworker Design**
2
Design Firm **Forsythe Design Inc.**
3
Design Firm **Type G Design**
4
Design Firm **Radiance Creative Studios**
5 - 7
Design Firm **Carr Design**
1.
Client Abraham Joshual Heschel
 Day School
Designers Tracy Sabin, Jim Davis
2.
Client Martha's Vineyard Farm
 Fresh Island Grown
Designers Tracy Sabin, Kathleen Forsythe
3.
Client Pasta Pasta
Designers Tracy Sabin, Mike Nelson

4.
Client RJL Investment Advisors
Designers Tracy Sabin, Jerry Ross
5.
Client ApotheCary Lab
Designer Colleen Carr
6.
Client Coast Music Therapy
Designer Colleen Carr
7.
Client My Stuff Bags Foundation
Designer Colleen Carr
(opposite)
Design Firm **Hansen Associates**
Client Woodfin Suites Hotel
Designers Ted Hansen,
 Colleen Carr

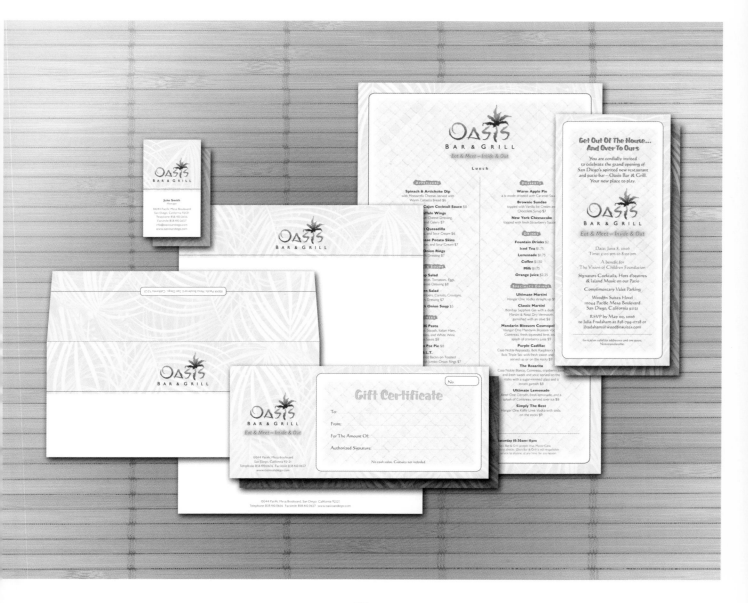

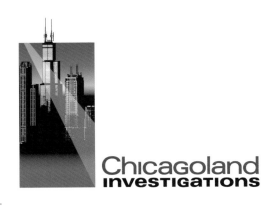

1.

2.

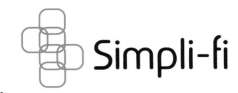

3.

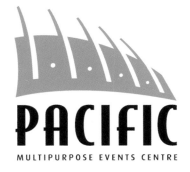

4.

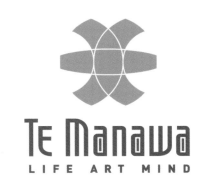

5.

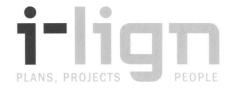

6.

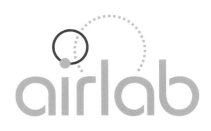

7.

8.

9.

10.

11.

12.

13.

GUSTO SYSTEMS™
INTEGRATED KNOWLEDGE & MEDIA

14.

15.

1		
Design Firm	**Carr Design**	
2		
Design Firm	**Hansen Associates**	
3 - 13		
Design Firm	**Cluster Creative Ltd**	
14, 15		
Design Firm	**Percept Creative Group**	
1.		
Client	Chicagoland Investigations	
Designer	Colleen Carr	
2.		
Client	Titania Jewelry	
Designers	Ted Hansen, Colleen Carr	
3.		
Client	Simpli-fi Ltd	
Designers	Briana Lee, Adam Errington	
4.		
Client	Litmus Research Ltd	
Designer	Adam Errington	
5.		
Client	Pacific Events Centre	
Designer	Adam Errington	
6.		
Client	Te Manawa	
Designers	Blake Enting, Adam Errington	

7.	
Client	ilign Ltd
Designer	Adam Errington
8.	
Client	airlab Ltd
Designers	Briana Lee, Adam Errington
9.	
Client	Immigration New Zealand
Designer	Adam Errington
10.	
Client	Emacs Ltd
Designers	Adam Errington, Briana Lee
11.	
Client	The Rum Company Ltd
Designers	Luke Morreau, Adam Errington
12.	
Client	NewTopo Ltd
Designer	Briana Lee
13.	
Client	Vice Café IBIS Hotels
Designer	Adam Errington
14.	
Client	Gusto Systems
Designers	Lewis Jenkins, Trent Agnew
15.	
Client	DNR Constructions
Designer	Lewis Jenkins

Ad-Lib

1.

&ersens

2.

AQUIUS

3.

the fireHouse
bar + restaurant

4.

ENLITE
TECHNOLOGY

5.

Harlotte xxx

6.

FEDERATION
couriers

7.

1 - 7
Design Firm **Percept Creative Group**
1.
 Client Ad-Lib
 Designer Lewis Jenkins
2.
 Client Andersens
 Designer Lewis Jenkins
3.
 Client Aquius
 Designer Lewis Jenkins
4.
 Client Constellation Hotel Group
 Designer Lewis Jenkins
5.
 Client Enlite
 Designers Lewis Jenkins, David Mills
6.
 Client Harlotte
 Designer Lewis Jenkins, Brad George

7.
 Client Federation Couriers
 Designers Lewis Jenkins, Trent Agnew
(opposite)
 Design Firm **Whitney Edwards, LLC**
 Client La De Da Women's Boutique
 Designer Charlene Whitney Edwards

HomeTheatre
Technologies

1.

2.

3.

4.

www.mjb.com.au

5.

6.

ConcertSeries

7.

1 - 7
Design Firm **Percept Creative Group**
1.
Client Home Theatre Technologies
Designer Lewis Jenkins
2.
Client Ireland Global
Designers Lewis Jenkins, Trent Agnew
3.
Client Maxi Pest
Designers Lewis Jenkins, Adam Fraser
4.
Client Megaluck
Designer Lewis Jenkins
5.
Client MJB
Designer Lewis Jenkins
6.
Client Namotu Island Fiji
Designer Lewis Jenkins

7.
Client NSW D.E.T. Concert Series
Designers Lewis Jenkins, Celine Brule
(opposite)
Design Firm **It's a Go!**
Client Fashion District
Designer Glenda Venn

38

FASHION
DISTRICT

1.

2.

3.

4.

5.

6.

7.

8.

youth development

9.

SEYMOR

10.

WAKAKIRRI

NATIONAL STORY FESTIVAL

GOT A STORY TO TELL?

11.

TEAMSPACE

12.

coaching insights

14.

SOULSA

MAKING FOOD GOOD

13.

ⵏⵏⵏⵏⵏⵏⵏ

THE DRILL HALL

15.

1 - 12		
Design Firm	**Percept Creative Group**	
13 - 15		
Design Firm	**It's a Go!**	
1.		
	Client	Ownerscorpe
	Designer	Lewis Jenkins
2.		
	Client	Oz Made
	Designer	Lewis Jenkins
3.		
	Client	Percept Creative Group
	Designer	Lewis Jenkins
4.		
	Client	Pipe King
	Designer	Lewis Jenkins
5.		
	Client	Rego to Go
	Designer	Lewis Jenkins
6.		
	Client	Scubaroos
	Designers	Lewis Jenkins, Trent Agnew
7.		
	Client	Selpro
	Designer	Lewis Jenkins

8.		
	Client	Tony Graham Real Estate
	Designers	Lewis Jenkins, Matt Green
9.		
	Client	SMP
	Designers	Lewis Jenkins, Trent Agnew
10.		
	Client	Seymor
	Designer	Lewis Jenkins
11.		
	Client	Wakakirri National Story Festival
	Designer	Lewis Jenkins
12.		
	Client	Teamspace
	Designers	Lewis Jenkins, Trent Agnew
13.		
	Client	Soulsa
	Designers	Eras Gouws, Glenda Venn
14.		
	Client	Coaching Insights
	Designer	Glenda Venn
15.		
	Client	Drill Hall
	Designer	Glenda Venn

People Development Solutions

1.

Coaching

2.

Team Development

3.

HUNTER GREEN

4.

STRATEGIC PUBLIC RELATIONS

5.

6.

7.

1 - 3
Design Firm **It's a Go!**
4 - 7
Design Firm **Fresh Creative**
1 - 3.
 Client Omnicor
 Designers Heidie Kumpf, Glenda Venn
4.
 Client Hunter Green Financial Advisors
 Designer Kirsten Jackes
5.
 Client Star PR
 Designer Kirsten Jackes
6.
 Client Ingenius Coaching
 Designer Kirsten Jackes
7.
 Client Grassroots IT
 Designer Kirsten Jackes

(opposite)
Design Firm **Rickabaugh Graphics**
Client University of Louisiana Monroe
Designer Dave Cap

1.

2.

3.

4.

5.

6.

7.

1 - 6
Design Firm **Fresh Creative**

7
Design Firm **Designs on You!**

1.
Client BIAQ
Designer Kirsten Jackes

2.
Client Corporate Stage Solutions
Designer Kirsten Jackes

3.
Client Niche Tableware
Designer Kirsten Jackes

4.
Client Star Marquees
Designer Kirsten Jackes

5.
Client Zen Apartments
Designer Kirsten Jackes

6.
Client Nuovon
Designer Kirsten Jackes

7.
Client Dayspring Family Care, PLLC
Designers Suzanna Stephens,
 Anthony Stephens

(opposite)
Design Firm **TBWA\TANGO Helsinki**
Client IADE (Institute for Art,
 Development and Education)
Designer Antero Kivikoski

1.

CarShopperDirect.com

2.

PATTON AMUSEMENT & VENDING

3.

COMMUNITY
TRUST
CREDIT UNION

4.

GALLO
CENTER
FOR THE
ARTS™

5.

...where miracles happen

6.

7.

8.

Conway's Fitness and Nutrition Center

9.

10.

11.

NATURAL GAS STORAGE LP

12.

n | s | b | i

Nova Scotia Business Inc.

Opportunity. Growth. Prosperity.

13.

14.

ACADIA

15.

1 - 9
Design Firm **Marcia Herrmann Design**
10 - 15
Design Firm **MT&L Public Relations Ltd.**

1.
Client Color the Skies
Designer Marcia Herrmann
2.
Client Car Shopper Direct
Designer Marcia Herrmann
3.
Client Patton Vending and Amusement
Designer Marcia Herrmann
4.
Client Community Trust Credit Union
Designer Marcia Herrmann
5.
Client Gallo Center for the Arts
Designer Marcia Herrmann
6.
Client Redwood
Designer Marcia Herrmann
7.
Client Pleasant Grounds
Designer Marcia Herrmann

8.
Client Cruisers
Designer Marcia Herrmann
9.
Client Shape and Fit
Designer Marcia Herrmann
10.
Client MT&L Public Relations Ltd.
Designer Paul Williams
11.
Client Joggins Fossil Cliffs
Designers Paul Williams, Danny Godfrey
12.
Client Alton Natural Gas Storage LP
Designer Danny Godfrey
13.
Client Nova Scotia Business Inc.
Designer Paul Williams
14.
Client AirFire Wireless Technology
Designer Paul Williams
15.
Client Acadia University
Designer Paul Williams

juju design party

1.

SUNDANCE SETTERS

2.

healthedge

3.

FROSTGIANT

4.

MÝRIN

5.

LANDSAFL

6.

7.

1
Design Firm **Designer Tuukka Tujula**
2
Design Firm **TL Design**
3
Design Firm **Monderer Design**
4 - 7
Design Firm **Frostgiant Design**

1.
Client JUJU Design Party
Designers Tuukka Tujula

2.
Client Sundance Setters
Designers Todd Lauer, Sally Puhalla

3.
Client HealthEdge Software, Inc.
Designers Stewart Monderer, Stuart McCoy

4.
Client Frostgiant Design
Designer Ymir Jonsson

5.
Client Mýrin
Designer Ymir Jonsson

6.
Client Landsafl
Designer Ymir Jonsson

7.
Client SG Design
Designer Ymir Jonsson
(opposite)
Design Firm **Frostgiant Design**
Client ÍAV
Designer Ymir Jonsson

ÍSLENSKIR AÐALVER

1.

2.

3.

4.

5.

6.

IMAGINE YOUR
FUTURE

7.

1
Design Firm **Mitzuk dCo**
2
Design Firm **Richard Zeid Design**
3
Design Firm **Lehman Graphic Arts**
4
Design Firm **Bryant Design**
5
Design Firm **Erwin Zinger graphic design**
6, 7
Design Firm **FiveStone**
1.
Client Ultimate Mystery Productions, LLC
Designer Stephen Mitzuk
2.
Client Earth First Farms
Designer Richard Zeid
3.
Client Bedrock Technologies, Inc.
Designer Lisa Lehman
4.
Client The Lab
Designer Kelly Vornauf Bryant

5.
Client Dynant Holding
Designer Erwin Zinger
6.
Client Xcentric
Designers Matt Pamer, Jason Locy
7.
Client Chic-fil-A
Designers Patricio Juarez, Jason Locy
(opposite)
Design Firm **Konsepti Advertising**
Client Finavia
Designer Timo Keinanen

1.

2.

3.

4.

5.

6.

7.

8.

OXFORD '06
REGATTA

9.

45TH

HAMMOND
M·E·M·O·R·I·A·L

10.

CHILDREN'S
ENVIRONMENTAL ALLIANCE

11.

wave
WHISPERERS

12.

DR

13.

Cable King

14.

DokuMount
DokuMount

15.

1 - 8
Design Firm **Shonkwiler Partners**
9 - 13
Design Firm **Spector Creative**
14, 15
Design Firm **Innovative Office Products
Marketing Department**

1.
Client Raymer's House of Music
Designer William Verrill
2.
Client KLVX Vegas PBS Television
Designer William Verrill
3.
Client Gotta Guy Handy Man
Designer William Verrill
4.
Client Ganix Bio-Technologies
Designer William Verrill
5, 6.
Client Las Vegas Motor Speedway
Designer William Verrill

7.
Client Las Vegas Champions & Celebrity
 Golf Celebration
Designer William Verrill
8.
Client Shonkwiler Partners
Designers Rick Willis, William Verrill
9.
Client Oxford Regatta
Designer Scott Spector
10.
Client Hammond Memorial
Designer Scott Spector
11.
Client Children's Environmental Alliance
Designer Scott Spector
12.
Client Wave Whisperers
Designer Scott Spector
13.
Client Designreaction.org
Designer Scott Spector
14, 15.
Client Innovative Office Products, Inc.
Designer Craig Magliane

1.

2.

3.

4.

5.

6.

7.

1
 Design Firm **1-Stop Design Shop, Inc.**
2
 Design Firm **Daniel Green Eye-D Design**
3, 4
 Design Firm **William Fox Munroe**
5 - 7
 Design Firm **3·Leaf Design**

1.
 Client Three Dogs Cafe
 Designer Christine M. Hennigan
2.
 Client Green Bay East High Red Devils
 Soccer Booster Club
 Designer Daniel Green
3.
 Client Kunzler
 Designers Amy Parker, Stephanie Bennett
4.
 Client Educate, Inc.
 Designers Mary Mallis, Matt Kennedy

5.
 Client Station Family Fund, Jon Bell
 Designer Theresa O'Toole
6.
 Client Legacy Healthcare Solutions,
 Entrane Harvey
 Designer Theresa O'Toole
7.
 Client Genome Corporation, Rita Duton
 Designer Theresa O'Toole
(opposite)
 Design Firm **In-house Marketing
 for Pioneer Millworks**
 Client Artisan Antique Floors
 Designers Deanna J. Varble, Iain Harrison

1.

2.

3.

4.

5.

6.

7.

1, 2
Design Firm **ydt~fonts**
3
Design Firm **CNI Advertising**
4 - 7
Design Firm **TAMAR Graphics**
1.
Client TeleRitter, GbR
Designer Yvonne Diedrich
2.
Client Bodo Vieth Antiques
Designer Yvonne Diedrich
3.
Client Alternative Energy Sources, Inc.
Designers Tim McNamara, Corey Shulda,
 Jake Lord
4.
Client Sakura Sushi Bar and Grill
Designer Tamar Wallace
5.
Client Dalton Publishing
Designer Tamar Wallace

6.
Client Business Click, LLC
Designer Tamar Wallace
7.
Client Guesture
Designer Tamar Wallace
(opposite)
Design Firm **ydt~fonts**
Client Temsamani Couture, Inc.
Designer Yvonne Diedrich

TEMSAMANI
COUTURE

1.

2.

3.

4.

5.

6.

7.

8.

9.

10.

11.

12.

lynncyr

13.

14.

15.

1.

2.

3.

4.

5.

6.

7.

1.

KAPPE ASSOCIATES INC.

2.

WOODINVILLE
WINE CELLARS

3.

4.

Global
2nd
Language

Your Perspective Matters™

5.

CET
Center for Entrepreneurship & Technology

6.

7.

1 - 2
Design Firm **18 Visions Design**
3 - 4
Design Firm **Image Ink Studio**
5 - 6
Design Firm **Jiva Creative**
7
Design Firm **DDC Engineers, Inc.**
In-House Graphic Department

1.
Client Williams Home Improvement
 and Remodeling
Designer Jason W. Feaga
2.
Client Kappe Associates, Inc.
Designer Jason W. Feaga
3.
Client Woodinville Wine Cellars
Designer Christopher McInerney

4.
Client Master Builders Association of King
 and Snohomish Counties,
 House Party 2006
Designers Deanna Miyamoto, Erica Ridout
5.
Client Global 2nd Language
Designer James Wagstaff
6.
Client Center for Entrepreneurship
 & Technology
Designer Jason Hall
7.
Client CopterViews, LLC
Designer Janette Fernandes
(**opposite**)
Design Firm **Paul Cartwright Branding**
Client Katie Denner for Elaine Day
Designer Paul Cartwright

1.

2.

CONDITIONOMICS, LLC

3.

fittingroup

4.

TESTA
THE RIGHT GEEK FOR THE JOB.

5.

BLACKTROUT

6.

THE
FRENCH
TART

Food is Love

7.

PRODUCT STRATEGY
N E T W O R K

profit from the experience

8.

9.

10.

i-Squared

making information make sense

12.

11.

Such-A-Much

PRODUCTIONS

prosebe

13.

14.

A Y R I N

15.

1 - 11
Design Firm **Fitting Group**
12 - 15
Design Firm **Jan Sabach Design**

1.
Client Black Knight Security
Designer Andrew O. Ellis

2.
Client Beechtree Realty Services, LLC
Designer T. J. Ladner

3.
Client Conditionomics, LLC
Designer T. J. Ladner

4.
Client Fitting Group
Designer Travis Norris

5.
Client Testa Consulting Services, Inc.
Designer Andrew O. Ellis

6.
Client Black Trout
Designer Michael Lotenero

7.
Client The French Tart
Designer Andrew O. Ellis

8.
Client Product Strategy Network
Designer Andrew O. Ellis

9.
Client Institute for Financial Independence
Designer Michael Henry

10.
Client Pelleon
Designer Jeff Kowal

11.
Client i-Squared
Designer Andrew O. Ellis

12.
Client Fresh Research
Designer Jan Sabach

13.
Client Such-A-Much Productions
Designer Jan Sabach

14.
Client prosebe
Designer Jan Sabach

15.
Client Ayrin Poor
Designer Jan Sabach

SusanJane™

1.

COMMUNITY INITIATIVE

2.

Where Knowledge Meets Nurture

Susan Gray School

4.

3.

5.

mcs graphic design

you name it…we'll create it!

6.

AppleEatsOrange 2006

7.

1			4.	
	Design Firm	**Kollar Design Associates, Inc.**	Client	Susan Gray School
2 - 4			Designer	Tom Ventress
	Design Firm	**Ventress Design Group**	5.	
5			Client	Galatasaray University
	Design Firm	**2FRESH, LLC**	Designers	Can Burak Bizer, Mustafa Oral
6			6.	
	Design Firm	**mcs graphic design**	Client	mcs graphic design
7			Designer	Cindy Dixon
	Design Firm	**Yellow60**	7.	
1.			Designer	Colin Marlow
	Client	SusanJane	**(opposite)**	
	Designers	Candice Kollar, Paul Nojima	Design Firm	**Pronk Graphics**
2.			Client	Pronk Graphics
	Client	Community Initiative	Designer	Tim Pronk
	Designer	Tom Ventress		
3.				
	Client	Zia Music Production		
	Designer	Tom Ventress		

MULTIMEDIA COMMUNICATIONS ★ ★ ★ ★ ★

- WEB SITE DESIGN AND DEVELOPMENT
- WEB SITE UPDATES
- FLASH | ACTIONSCRIPTING
- BUSINESS CARDS / BROCHURES / MAILERS
- DIGITAL AND TRADITIONAL ILLUSTRATION
- VEHICLE AND SIGN GRAPHICS
- CORPORATE IDENTITY | BRANDING
- MARKETING | CONSULTING
- PRINT DESIGN AND OUTPUT
- PROFESSIONAL RESULTS
- COMPETITIVE RATES
- CONTACT PRONK GRAPHICS TODAY

info@pronkgraphics.com

www.pronkgraphics.com

CREATIVE DEVELOPMENT FOR DIGITAL AND PRINT! Phone / Fax: 519.770.4627

MULTIMEDIA COMMUNICATIONS

Phone / Fax: 519.770.4627 TIM PRONK

www.pronkgraphics.com

1.

2.

3.

4.

5.

6.

7.

1 - 3
Design Firm **Addison Whitney**
4 - 7
Design Firm **Alien Identity**
1.
Client Simplay
Designers Kimberlee Davis, Trey Walsh,
 Kristin Hager
2.
Client Silicon Image
Designers Kristin Hager, Kimberlee Davis,
 Trey Walsh
3.
Client Ambrilia Biopharma
Designers Trey Walsh, Kristin Hager,
 Kimberlee Davis

4.
Client A Shade Darker
Designer Dennis Derammelaere
5.
Client Rivertown Business Builders
Designer Dennis Derammelaere
6, 7.
Client Lincoln Street Builders
Designer Dennis Derammelaere
(opposite)
Design Firm **RPM Advertising**
Client Horseshoe Casino
Designer Brad Gordee

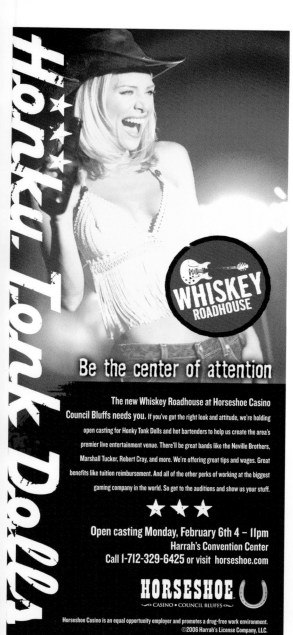
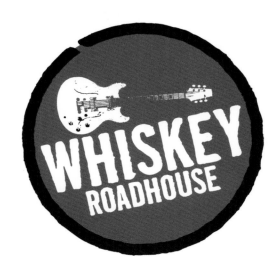
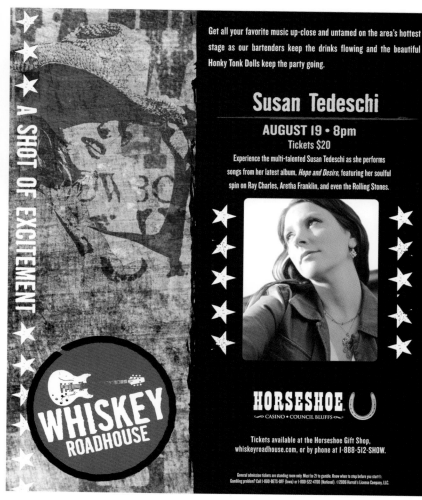

1.

2.

3.

4.

5.

6.

7.

8.

derma clinique

9.

SOUTH LAKE SURGICAL

10.

HESSBURG
& CARLSON
BUILDERS, INC.

11.

CFWEST
CENTRAL FLORIDA WEST

12.

ROSARIO
AUTOMOTIVE GROUP

13.

E-Z BREEZE

14.

SOUTH LAKE
INTERNAL
MEDICINE

15.

1.

2.

3.

4.

5.

6.

7.

1 - 5
Design Firm **FutureBrand Brand Experience**
6, 7
Design Firm **art270, Inc.**
1.
Client Bahrain World Trade Center
Designers Diego Kolsky, Cheryl Hill
2.
Client Dubai Aerospace Enterprise
Designers Diego Kolsky, Cheryl Hills,
 Brendanb Oneill, Mike Williams
3.
Client Dubai World
Designers Mario Natarelli, Diego Kolsky,
 Alex Sugai
4.
Client Forsa
Designers Mario Natarelli, Carol Wolf
5.
Client Taqa
Designers Diego Kolsky, Mike Williams

6.
Client Galaxy Soccer Club
Designers John Opet, Carl Mill
7.
Client Keith Mill & Friends
Designers John Opet, Carl Mill
(opposite)
Design Firm **FutureBrand Brand Experience**
Client Ayla

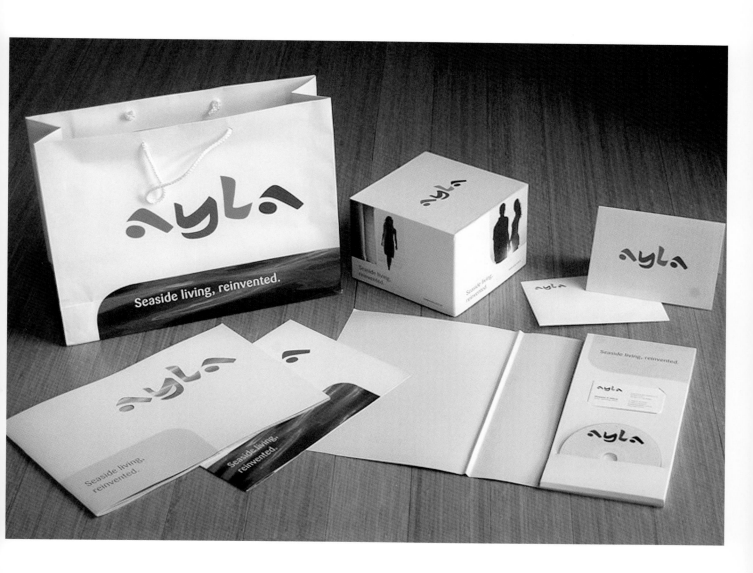

Jumeirah Park

1.

corkscrew

2.

Joyful Living

OVATION

3.

4.

5.

6.

7.

1
Design Firm **FutureBrand Brand Experience**
2 - 7
Design Firm **A3 Design**
1.
Client Jumeirah Park
Designers Alex Sugai, Mike Williams
2.
Client Corkscrew Wine Bar
Designers Alan Altman, Amanda Altman
3.
Client Mattamy Home—Ovation
Designers Alan Altman, Lauren Gualdoni
4.
Client Goody Paint
Designers Alan Altman, Amanda Altman
5.
Client Bryant & Duffey Optics
Designers Alan Altman, Amanda Altman,
 Lauren Gualdoni

6.
Client Net Winners
Designers Alan Altman, Amanda Altman
7.
Client Hot Saké
Designers Alan Altman, Amanda Altman
(opposite)
Design Firm **FutureBrand Brand Experience**
Client Exomos
Designers Tom Li, Brendan Oneill,
 Mike Williams, Carol Wolf,
 Avrom Tobias

1.

2.

3.

4.

5.

6.

7.

8.

9.

10.

PLANET21SALON

11.

zenprise

12.

yousENDit

13.

iC*NCLUDE

14.

Jitterbit

15.

1 - 11
Design Firm **A3 Design**
12 - 15
Design Firm **Connie Hwang Design**
1 - 3.
 Client Mattamy Homes
 Designers Alan Altman, Amanda Altman
4, 5.
 Client Mattamy Homes
 Designer Alan Altman
6, 7.
 Client Crown Communications
 Designers Alan Altman, Amanda Altman
8.
 Client Griffith Choppers
 Designers Alan Altman, Amanda Altman
9.
 Client Wilmington
 Designers Alan Altman, Amanda Altman,
 Lauren Gualdoni
10.
 Client Ortiz & Schick
 Designers Alan Altman, Amanda Altman

11.
 Client Planet 21 Salon
 Designers Alan Altman, Amanda Altman
12.
 Client Zenprise, Inc.
 Designer Connie Hwang
13.
 Client YouSendIt, Inc.
 Designer Connie Hwang
14.
 Client iConclude, Inc.
 Designer Connie Hwang
15.
 Client Jitterbit, Inc.
 Designer Connie Hwang

1.

2.

3.

The
Mono Center
AT CENTRAL PARK

Enjoy Your Escape!

4.

real estate the property pros

5.

6.

Kosciusko County
COMMUNITY
FOUNDATION

Where Donor Dreams Shine.

7.

1			5.		
	Design Firm	**30sixty Advertising+Design, Inc.**		Client	Dillion The Property Pros
2				Designer	Lori Lucas
	Design Firm	**studioerin**	6.		
3 - 7				Client	Womack Restaurants
	Design Firm	**MillerWhite, LLC**		Designer	Noah Ostby
1.			7.		
	Client	King's Seafood Company		Client	Kosciusko County Community
	Designers	Henry Vizcarra, David Fuscellaro,			Foundation
		Lee Barett, Mark Prudeaux		Designer	Lori Lucas
2.			**(opposite)**		
	Client	Gatsby Music		Design Firm	**Hornall Anderson**
	Designer	Erin Starks			**Design Works LLC**
3.				Client	Boston Market
	Client	Conservatory of Music		Designers	Jack Anderson, James Tee,
	Designer	Noah Ostby			Tiffany Place, Lauren DiRusso,
4.					Kris Delaney, John Anderle
	Client	Carmel Clay Parks and Recreation			
	Designer	Atsu Kpotufe			

1.

2.

3.

4.

5.

6.

7.

1
 Design Firm **Leila Singleton**
2, 3
 Design Firm **Kevin Hall Design**
4
 Design Firm **Howard York**
5 - 7
 Design Firm **TranSystems Corporation**
1.
 Client Webster Home Maintenance
 Designer Leila Singleton
2, 3.
 Client SPLASH, Ltd.
 Designer Kevin Hall
4.
 Client Metropolitan Gallery
 Designer Howard York
5.
 Client TranSystems Corporation
 Designers Howard York, Monica Kominami

6.
 Client Hudson Group—Halifax Market
 Designers Howard York, Monica Kominami
7.
 Client Washington Metropolitan Area
 Transportation Authority
 Designers Howard York, Monica Kominami,
 Ilene Hinden
(opposite)
 Design Firm **Karacters Design Group**
 Client Northlands
 Designer Marsha Larkin

1.

2.

3.

4.

5.

6.

7.

8.

9.

MIRAMONT
LIFESTYLE FITNESS

10.

OpenView Forum International
ADVOCACY ▪ COMMUNITY ▪ EDUCATION

11.

12.

13.

BURNS MARKETING COMMUNICATIONS

14.

15.

1 - 15		
Design Firm	**Burns Marketing Communications**	
1.		
Client	Cartasite	
Designer	Gregg Lulofs	
2.		
Client	Colorado BioScience Association	
Designer	Travis Barhaug	
3.		
Client	Eheart Interior Solutions	
Designers	Travis Barhaug, Shelby Montross	
4.		
Client	Highland Meadows	
Designer	Travis Barhaug	
5.		
Client	Husky International Electronics	
Designer	Gregg Lulofs	
6.		
Client	ISRA Inc.	
Designer	Travis Barhaug	
7.		
Client	LBN Insurance	
Designer	Gregg Knoll	

8.		
Client	The O'Connor Group	
Designer	Gregg Knoll	
9.		
Client	Mountain Avenue	
Designers	Shelby Montoss, Gregg Lulofs	
10.		
Client	Miramont Lifestyle Fitness	
Designer	Travis Barhaug	
11.		
Client	OpenView Forum International	
Designer	Travis Barhaug	
12.		
Client	Kazoie	
Designer	Travis Barhaug	
13.		
Client	Twin Peaks Utilities and Infrastructure	
Designer	Greg Knoll	
14.		
Client	Burns Marketing Communications	
Designers	Travis Barhaug, Dave Bach	
15.		
Client	Universal Well Site Solutions	
Designer	Greg Knoll	

zango

1.

2.

revalesio

3.

wetpaint

4.

urban visions

5.

SCREAMER

6.

7.

1.

2.

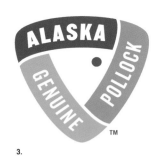

3.

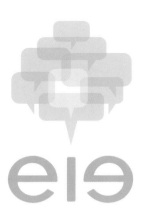

4.

CO
RR
ID
OR
15

5.

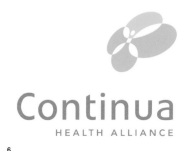

Continua
HEALTH ALLIANCE

6.

CitationShares

7.

1 - 7
Design Firm **Hornall Anderson Design Works LLC**

1.
Client Majestic America Line
Designers Jack Anderson, Andrew Wicklund,
 Peter Anderson, Ensi Mofasser,
 Belinda Bowling, Kathleen Gibson
2.
Client Redfin
Designers Jack Anderson, David Bates
 Yuri Shvets
3.
Client Genuine Alaska Pollock Producer
Designers Katha Dalton, Elmer dela Cruz
4.
Client Entrepreneurs and Innovators
 for the Environment
Designers Jack Anderson, Yuri Shvets
5.
Client Corridor 15
Designers Jack Anderson, Peter Anderson

6.
Client Continua Health Alliance
Designers Jack Anderson, Kathy Saito,
 Yuri Shvets, Belinda Bowling
7.
Client CitationShares
Designers Jack Anderson, Kathy Saito,
 Henry Yiu, Elmer dela Cruz,
 Sonja Max, Hayden Schoen
(opposite)
Design Firm **Evenson Design Group**
Client Angel City Gym
Designers Stan Evenson, Mark Sojka

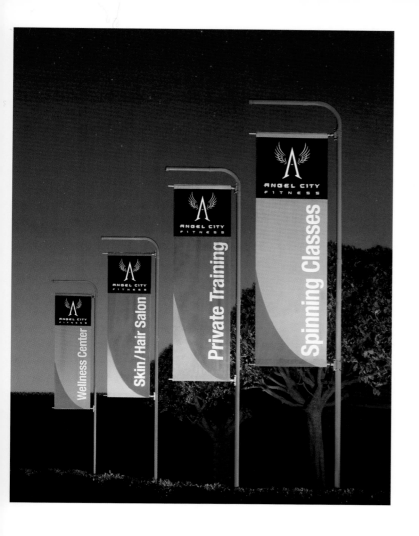

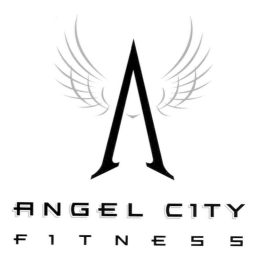

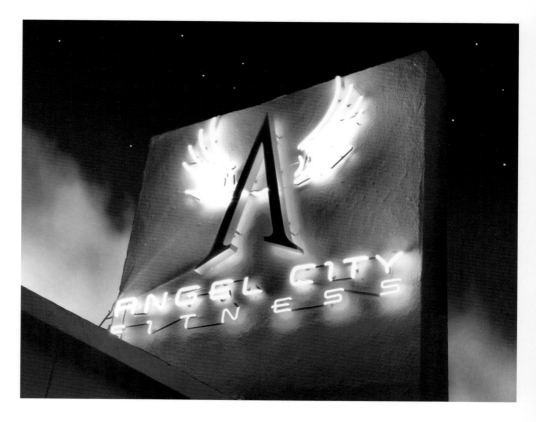

1.

ANDREW SEED III

2.

3.

4.

5.

6.

7.

Greater Englewood
chamber of commerce

bringing business together™

8.

9.

10.

11.

12.

13.

14.

15.

1		
Design Firm	**Hornall Anderson Design Works LLC**	
2 - 15		
Design Firm	**CATALYST creative, inc.**	
1.		
Client	Seattle Seahawks	
Designers	Jack Anderson, Andrew Wicklund, Elmer dela Cruz, Peter Anderson, Nathan Young	
2.		
Client	Andrew W. Seed III	
Designer	Jeanna Pool	
3.		
Client	Artisan Interiors and Remodeling	
Designer	Jeanna Pool	
4.		
Client	Back to Basics Health Center	
Designer	Jeanna Pool	
5.		
Client	Big Bear Mortgage Processing	
Designer	Jeanna Pool	
6.		
Client	Bretz Tec	
Designer	Jeanna Pool	
7.		
Client	Chris Sierk, DDS	
Designer	Jeanna Pool	

8.	
Client	Greater Englewood Chamber of Commerce
Designer	Jeanna Pool
9.	
Client	Equity Wise Reverse Mortgage Specialists
Designer	Jeanna Pool
10.	
Client	The Institute of Food Science and Engineering
Designer	Jeanna Pool
11.	
Client	James C. Downs, DMD, PC
Designer	Jeanna Pool
12.	
Client	Linderella Coaching
Designer	Jeanna Pool
13.	
Client	Heartfelt Therapeutic Massage
Designer	Jeanna Pool
14.	
Client	Jon Sierk, DDS
Designer	Jeanna Pool
15.	
Client	NAWBO—Denver Chapter
Designer	Jeanna Pool

1.

2.

3.

4.

Se·man·tix

5.

6.

7.

1, 2
Design Firm **CATALYST creative, inc.**
3 - 7
Design Firm **Evenson Design Group**
1.
Client Michael Schock Architects
Designer Jeanna Pool
2.
Client Shine Life Coaching
Designer Jeanna Pool
3.
Client CoAbode
Designers Stan Evenson, Mark Sojka,
 Jerry Lee Keyes
4.
Client Westside Neighborhood School
Designers Stan Evenson, Kera Scott,
 Melanie Usas, Tricia Rauen
5.
Client Jamil Barrie
Designers Stan Evenson, Mark Sojka

6.
Client WellPoint
Designers Stan Evenson, Kera Scott,
 Melleta Marx
7.
Client Conservation Breeding
 Specialist Group
Designers Stan Evenson, Mark Sojka
(opposite)
Design Firm **Colin Magnuson Creative**
Client Joeseppi's: Eat at Joe's
Designer Colin Magnuson

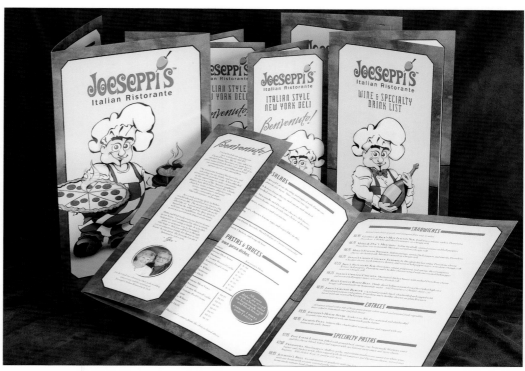

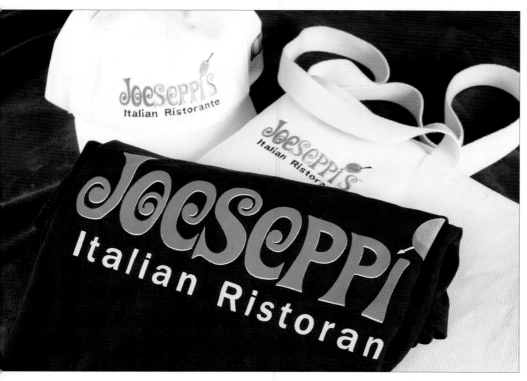

1.

2.

3.

4.

5.

6.

ciena

7.

1 - 6
Design Firm **Evenson Design Group**
7
Design Firm **Hornall Anderson
Design Works LLC**

1.
Client Red Yard
Designer Stan Evenson

2.
Client Floral Fruit Company
Designers Stan Evenson, Melanie Usas

3.
Client Family Camp
Designers Stan Evenson, Mark Sojka,
 Katja Loesch

4.
Client Peik Performance
Designers Stan Evenson, Mark Sojka,
 Katja Loesch

5.
Client Mogomedia
Designers Stan Evenson, Mark Sojka

6.
Client Vistamar School
Designers Stan Evenson, Mark Sojka

7.
Client Ciena
Designers Jack Anderson, Andy Davidhazy,
 Holly Craven, Sonja Max, Yuri Shvets,
 Andrew Wicklund, Kris Delaney

(opposite)
Design Firm **Hornall Anderson
Design Works LLC**
Client Kinetix Living
Designers Jack Anderson, David Bates,
 Yuri Shvets

1.

2.

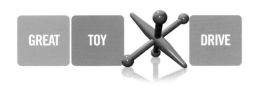

3.

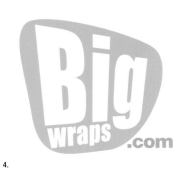

4.

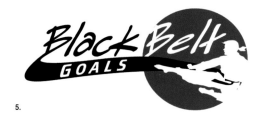

5.

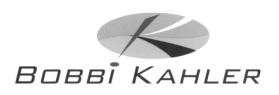

6.

7.

8.

Becky Wehrli, CLTC

9.

GTM
CONSTRUCTION, INC

10.

Joanna
Tompkin, CCIM
Mortgage Services

11.

Mandy Allen
Metal Arts

12.

Unforgettable
Honeymoons

13.

thirty second spot

14.

Balaam Landscape Services

15.

1 - 15
Design Firm **PangHansen Creative Group**

1 - 3.
Client KGW-TV
Designer Chris Hansen

4.
Client Big Wraps
Designer Chris Hansen

5.
Client Black Belt Business Solutions
Designer Lili Pang

6.
Client Bobbi Kahler
Designer Lili Pang

7.
Client Christi Gallery
Designer Lili Pang

8.
Client Clear Channel
Designer Chris Hansen

9.
Client Becky Wehrli
Designer Lili Pang

10.
Client GTM Construction
Designer Chris Hansen

11.
Client Joanna Tompkin
Designer Lili Pang

12.
Client Mandy Allen Metal Arts
Designer Lili Pang

13.
Client Unforgettable Honeymoon
Designer Lili Pang

14.
Client Thirty Second Spot
Designer Chris Hansen

15.
Client Balaam Landscaping Services
Designer Lili Pang

1.

2.

3.

4.

5.

PERSONAL **SOLUTIONS**, LLC.

6.

7.

1 - 3
Design Firm **PangHansen Creative Group**
4 - 7
Design Firm **Allison Chess Design**
1.
 Client Northwest Viz
 Designer Chris Hansen
2.
 Client White Van Shuttle
 Designer Lili Pang
3.
 Client Clear Channel
 Designer Lili Pang
4.
 Client Set in Motion
 Designer Allison Chess
5.
 Client U.S. Department of Health &
 Human Services
 Designer Allison Chess

6.
 Client Personal Solutions, LLC
 Designer Allison Chess
7.
 Client Bus Stop Saloon
 Designer Allison Chess
(opposite)
 Design Firm **Evenson Design Group**
 Client GalleryC
 Designer Mark Sojka

1.

2.

3.

4.

FRENCH LEAVE

5.

6.

7.

1 - 3
Design Firm **Kinesis, Inc.**
4
Design Firm **Booksign**
5 - 7
Design Firm **Sommese Design**

1.
Client — Red Snail
Designers — Shawn Busse, Natasha Kramskaya

2.
Client — Smart's Publishing
Designers — Shawn Busse, Anna Magruder

3.
Client — Sweetgrass Natural Fibers
Designers — Shawn Busse, Michelle Cheney

4.
Client — Booksign
Designer — Pirjo Toroskainen

5.
Client — Lauth Development
Designers — Lanny Sommese, Kristin Sommese, Ryan Russell

6.
Client — Penn State School of Visual Arts
Designers — Lanny Sommese, Ryan Russell

7.
Client — Lauth Development
Designers — Lanny Sommese, Ryan Russell

(opposite)
Design Firm **Evenson Design Group**
Client — Synergy Café and Lounge
Designers — Stan Evenson, Katja Loesch

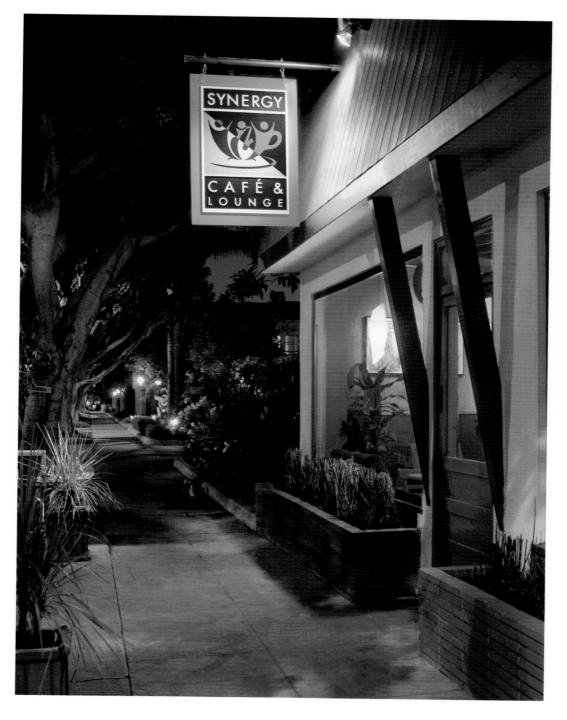

andramatin

1.

when food and fun become one

2.

BALE PARE

A different shopping experience

3.

nusadua
BALIDESA

4.

léboyé

5.

SENS

6.

GALERI
INGGIL

7.

KAYUMANIS

8.

9.

THE **BRAND** RENOVATOR℠

10.

11.

APOLLO COMPANY

12.

THE GOLDNER GROUP

13.

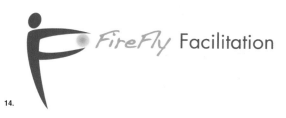

FireFly Facilitation

14.

HORIZONS
FINANCIAL ADVISORS

15.

1 - 9
Design Firm **LeBoYe**
10 - 15
Design Firm **Design That Works**
Communications Inc.

1.
Client Andramatin Architect
Designers Ignatius Hermawan Tanzil,
 Yan Mursid
2, 3.
Client PT Lyman
Designers Ignatius Hermawan Tanzil,
 Cecil Mariani
4.
Client PT Transpasific Group
Designers Ignatius Hermawan Tanzil,
 Adi Handoyo Gunawan
5.
Client LeBoYe
Designers Ignatius Hermawan Tanzil,
 Ismiaji Cahyono
6.
Client LeBoYe
Designer Ignatius Hermawan Tanzil
7.
Client Galeri Inggil
Designer Ignatius Hermawan Tanzil

8.
Client Kayumanis Private Villa & Spa
Designers Ignatius Hermawan Tanzil,
 The Brand Renovator
9.
Client Meradelima Restaurant
Designer Ignatius Hermawan Tanzil
10.
Client GTM Construction
Designer Linda L. McCulloch
11.
Client Key Construction Services, Inc.
Designer Linda L. McCulloch
12.
Client Apollo Company
Designer Linda L. McCulloch
13.
Client The Goldner Group
Designer Linda L. McCulloch
14.
Client FireFly Facilitation
Designer Linda L. McCulloch
15.
Client Horizons Financial Advisors
Designer Linda L. McCulloch

1.

2.

3.

elite

4.

RASUNA
EPICENTRUM

5.

GRAND CHAMPA
A HAVEN REVEALED

6.

JAVA BOOKS
INDONESIA

7.

1 - 7
Design Firm **LeBoYe**
1.
Client PT Bika Parama Cipta
Designers Ignatius Hermawan Tanzil,
 Ismiaji Cahyono
2.
Client PT Agung Podomoro
Designer Ignatius Hermawan Tanzil
3.
Client Dirgahayu Offset
Designers Ignatius Hermawan Tanzil,
 Adi Handoyo Gunawan
4.
Client Elite Grahacipta
Designers Ignatius Hermawan Tanzil,
 Ayodhia Soemardjan
5.
Client PT Bakrie Land
Designers Ignatius Hermawan Tanzil,
 Ngah Muliawati

6.
Client PT Dharmala Gandaria Permai
Designers Ignatius Hermawan Tanzil,
 Ismiaji Cahyono
7.
Client Java Books
Designers Ignatius Hermawan Tanzil,
 Albertus H. Tedjasukmana
(opposite)
Design Firm **LeBoYe**
Client PT Lima Roti
Designers Ignatius Hermawan Tanzil,
 Felicia Tirtaputra

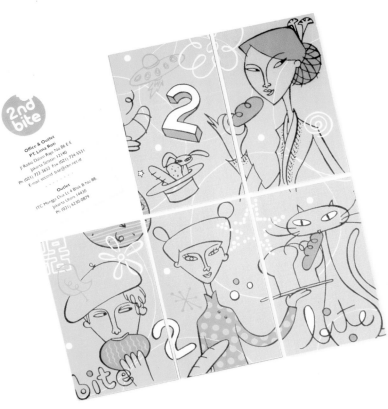

Office & Outlet
PT Lima Roti
Jl Radio Dalam Raya No 86 E E
Jakarta Selatan 12140
Ph (021) 722-3652 Fax (021) 724-5531
E-mail second_bite@cbn.net.id

Outlet
ITC Mangga Dua Lt 4 Blok B No 88
Jakarta Utara 14430
Ph (021) 6230-0879

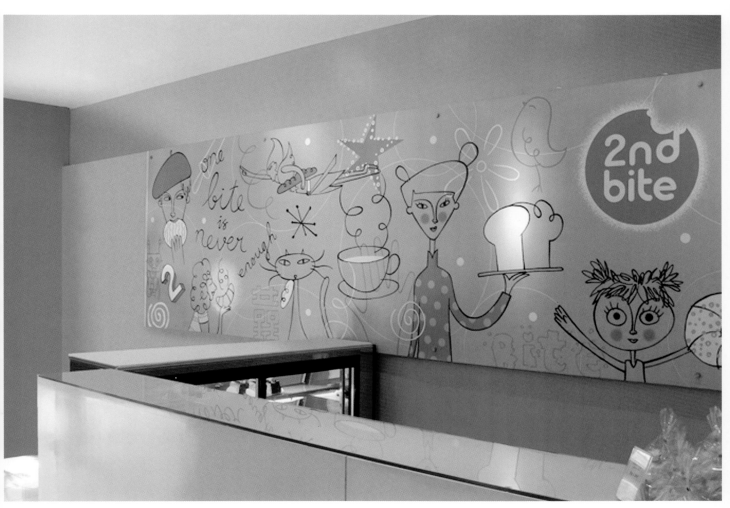

1.

2.

lifestyle

photography • videography

3.

4.

5.

PRA MESTHA

the spirit of nature

6.

SAMUEL

Your lifelong investment partner

7.

1 - 7
Design Firm **LeBoYe**
1.
Client Kartika Soekarno Foundation
Designers Ignatius Hermawan Tanzil,
 Imelda Dewantoro
2.
Client Kembang Goela Restaurant
Designers Ignatius Hermawan Tanzil,
 Novita Angka
3.
Client Lifestyle
Designers Ignatius Hermawan Tanzil,
 Grace Patricia
4.
Client Martin Westlake
Designers Ignatius Hermawan Tanzil,
 Ismiaji Cahyono
5.
Client Pavilions Private Villas
Designers Ignatius Hermawan Tanzil,
 Noor Wulan

6.
Client PT Lembang Permata
Designers Ignatius Hermawan Tanzil,
 Yan Mursid
7.
Client Samuel Sekuritas Indonesia
Designers Ignatius Hermawan Tanzil,
 Albert H. Tedjasukmana
(opposite)
Design Firm **Maycreate**
Client The Ark
Designer Brian May

1.

2.

3.

4.

5.

6.

7.

8.

9.

10.

11.

12.

13.

14.

15.

1.

TAUZIA

Business Development

2.

3.

THE SUMMIT

KELAPA GADING

4.

TRANSPACIFIC

5.

to-yè

6.

THE
SOVEREIGN
KEMANG

7.

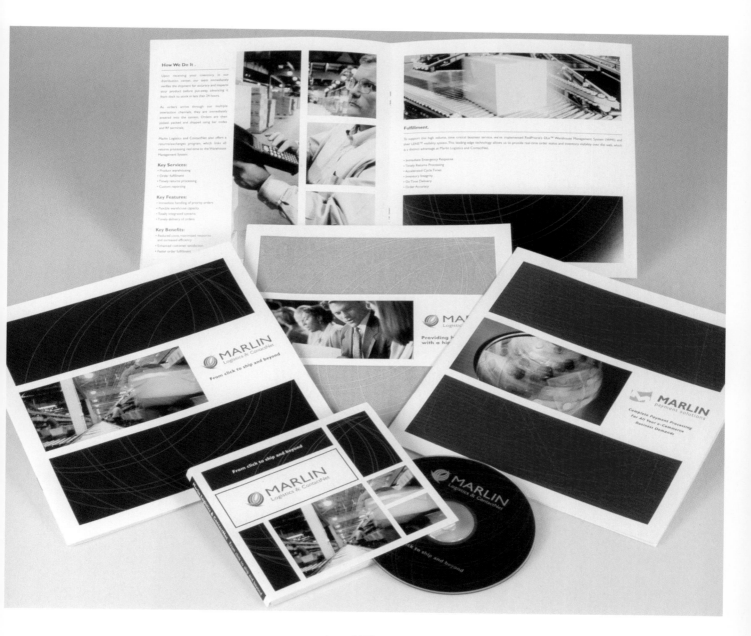

T O P I A R Y

1.

T O P I A R Y

2.

T O P I A R Y

3.

4.

5.

6.

NAVIGATOR
CORPORATE SERVICES

7.

1 - 5
Design Firm **LeBoYe**
6, 7
Design Firm **Arcaris Creative**
1 - 3.
Client LeBoYe
Designers Ignatius Hermawan Tanzil,
 Noor Wulan
4.
Client PT Graha Realty Kencana
Designers Ignatius Hermawan Tanzil,
 Ayodhia Soemardjan
5.
Client Warung Enak Restaurant
Designers Ignatius Hermawan Tanzil,
 Grace Patricia
6.
Client FoodieSmart
Designer Gabriella Sousa

7.
Client United Van Lines
Designers Gabriella Sousa, Sandra Campbell
(opposite)
Design Firm **Homesteaders Life Company**
 Marketing Communications
Client Homesteaders Life Company
Designer Jeremy Schultz

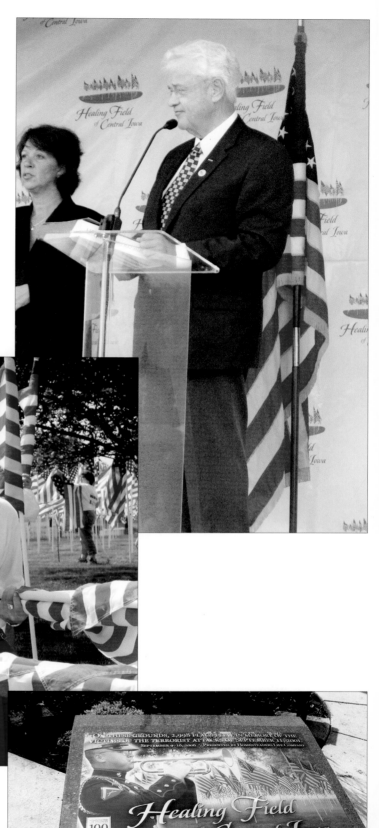

1.

2.

3.

4.

5.

6.

7.

8.

9.

10.

11.

12.

13.

ILLINOIS
Holocaust
Museum & Education
Center

14.

15.

1 - 9
Design Firm **Gabriella Sousa Designs**
10 - 15
Design Firm **McKnight Kurland Baccelli**

1.
Client Pinnacle Investment
Designer Gabriella Sousa
2.
Client One Life Wellness
Designer Gabriella Sousa
3.
Client TL Services
Designer Gabriella Sousa
4.
Client Lisa Mininni Photography
Designer Gabriella Sousa
5.
Client KA Health & Fitness
Designer Gabriella Sousa
6.
Client Jules Ross
Designer Gabriella Sousa
7.
Client GT Autoworx
Designer Gabriella Sousa

8.
Client Gabriella Sousa Designs
Designer Gabriella Sousa
9.
Client Dhaka Project
Designer Gabriella Sousa
10.
Client Aquaz, Inc.
Designers McKnight Kurland Baccelli
11.
Client CAP Foundation
Designers McKnight Kurland Baccelli
12.
Client Connexis, LLC
Designers McKnight Kurland Baccelli
13.
Client High Throughput Genomics, Inc.
Designers McKnight Kurland Baccelli
14.
Client Illinois Holocaust Museum &
 Education Center
Designers McKnight Kurland Baccelli
15.
Client Media Directions
Designers McKnight Kurland Baccelli

1.

2.

3.

4.

5.

6.

7.

1 - 7
Design Firm **Tom Fowler, Inc.**

1, 2.
Client The Maritime Aquarium at Norwalk
Designers Thomas G. Fowler,
 Elizabeth P. Ball

3.
Client Connecticut Grand Opera
 & Orchestra
Designers Thomas G. Fowler,
 Elizabeth P. Ball,
 Stephanie Goos Johnson

4.
Client California WineWorks
Designer Elizabeth P. Ball

5.
Client ServiceMacs
Designer Elizabeth P. Ball

6.
Client Unilever Creative Package
 Design Department
Designers Thomas G. Fowler,
 Elizabeth P. Ball

7.
Client Willi's Wine Bar, Paris, France
Designer Thomas G. Fowler

(opposite)
Design Firm **Evenson Design Group**
Client Blake Brand Growers
Designers Stan Evenson, Mark Sojka,
 Wayne Watford

PENCIL SHARPENER | SACAPUNTAS | TAILLE-CRAYON

1.

2.

3.

4.

5.

6.

7.

1			6.	
Design Firm	**Tom Fowler, Inc.**		Client	Elan Boats
2 - 7			Designers	Joe Alarie, Scott Donald
Design Firm	**Alarie Design Associates, Inc.**		7.	
1.			Client	Greenbriar Landscape
Client	Acme United Corporation		Designers	Scott Donald, Joshua Bowens
Designer	Mary Ellen Butkus		**(opposite)**	
2.			Design Firm	**Maycreate**
Client	Baerncopf Homes		Client	Airnet Group
Designer	Scott Donald		Designer	Brian May
3.				
Client	Captain and the Cowboy			
Designer	Scott Donald			
4.				
Client	Earl of Sandwich			
Designers	Joe Alarie, Scott Donald			
5.				
Client	Rally Stores			
Designers	Joe Alarie, Scott Donald			

1.

2.

3.

4.

5.

6.

7.

8.

9.

10.

11.

12.

13.

14.

15.

1.

2.

3.

4.

MUNICIPALLIANCE

Community Coalition Against Substance Abuse

5.

new american + raw bar

6.

7.

1, 2
Design Firm **Peterson Ray & Company**
3 - 7
Design Firm **PM Design**
1.
 Client Crossroads Coffeehouse
 & Music Co.
 Designer Scott Ray
2.
 Client Elysium Concierge
 Designer Miler Hung
3.
 Client Brick Banking
 Designers Philip Marzo, Sandy Haight
4.
 Client Dunellen Hotel
 Designer Philip Marzo
5.
 Client Municipal Alliance
 Designer Philip Marzo

6.
 Client One Restaurant
 Designer Philip Marzo
7.
 Client Roots Steakhouse
 Designer Philip Marzo
(opposite)
 Design Firm **Sayles Graphic Design**
 Client Beaverdale Books
 Designer John Sayles

1.

2.

3.

BRIDGEWATER BANK

4.

Joshua
Hag und
Memorial Peace Scholarship Fund
www.joshuahaglund.com

5.

matreks

6.

MASSMAN
Automation Designs, LLC

7.

1, 2
 Design Firm **Anastasia Design**
3
 Design Firm **Homesteaders Life Company**
 Marketing Communications
4 - 7
 Design Firm **Hendler-Johnston, LLC**
1.
 Client A&E Fire Protection
 Designers Anastasia Tanis,
 Heather Weinberg
2.
 Client Masona Grill
 Designers Anastasia Tanis,
 Heather Weinberg
3.
 Client Homesteaders Life Company
 Designer Jeremy Schultz
4.
 Client Bridgewater Bank
 Designers Chris Hendler,
 Chris Zastoupil

5.
 Client Haglund Memorial Fund
 Designer Chris Hendler
6.
 Client Matreks, LLC
 Designer Chris Zastoupil
7.
 Client Massman Automation Designs, LLC
 Designer Chris Hendler
(opposite)
 Design Firm **StudioMoon/San Francisco**
 Client Caitlin Stewart-Jones,
 WSJ Design Studio
 Designer Tracy Moon

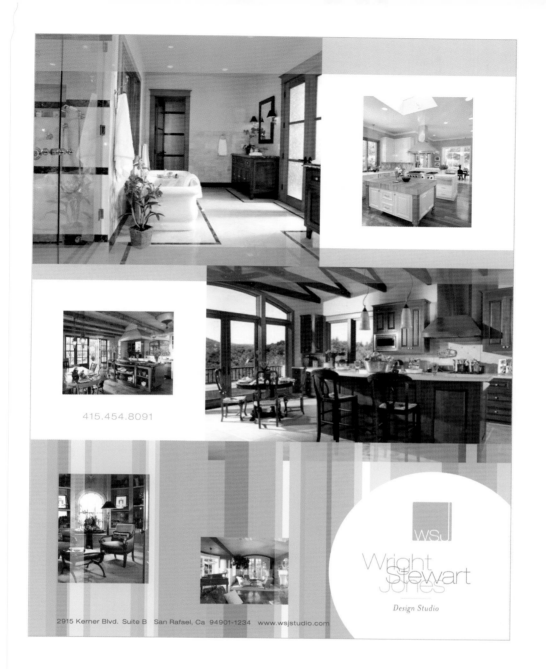

415.454.8091

2915 Kerner Blvd. Suite B San Rafael, Ca 94901-1234 www.wsjstudio.com

121 Winding Way
Residential Kitchen

1.

2.

3.

4.

5.

6.

7.

8.

9.

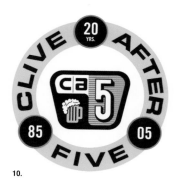

10.

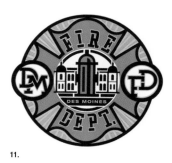

11.

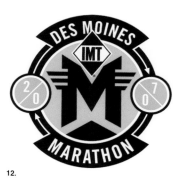

12.

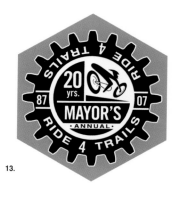

13.

14.

15.

1 - 15

Design Firm **Sayles Graphic Design**

1.
| Client | AgentsBeware.com |
| Designer | John Sayles |

2.
| Client | Alternative Storage |
| Designer | John Sayles |

3.
| Client | AquaZul |
| Designer | John Sayles |

4.
| Client | Bass Street Chop House |
| Designer | John Sayles |

5.
| Client | b-clean |
| Designer | John Sayles |

6.
| Client | Berrington Marble |
| Designer | John Sayles |

7.
| Client | Des Moines Playhouse |
| Designer | John Sayles |

8.
| Client | Busy Bee Tailoring |
| Designer | John Sayles |

9.
| Client | Campbell's Nutrition |
| Designer | John Sayles |

10.
| Client | Clive Jaycees "Clive After Five" |
| Designer | John Sayles |

11.
| Client | Des Moines Fire Department |
| Designer | John Sayles |

12.
| Client | Des Moines Marathon 2007 |
| Designer | John Sayles |

13.
| Client | Des Moines Parks and Recreation 2007 Mayor's Bike Ride |
| Designer | John Sayles |

14.
| Client | Iowa Talk |
| Designer | John Sayles |

15.
| Client | Des Moines Public Library |
| Designer | John Sayles |

125

1.

2.

3.

4.

5.

6.

7.

1 - 7
Design Firm **Sayles Graphic Design**
1.
Client Accelerated Bail Bonds
Designer John Sayles
2.
Client Des Moines Symphony Alliance
Designer John Sayles
3.
Client Dirty Side Down Motocross Racing
Designer John Sayles
4.
Client Duane Tinkey Photographer
Designer John Sayles
5.
Client Eight Ball 2006
Designer John Sayles
6.
Client Eshipping
Designer John Sayles

7.
Client Forest Avenue Library
 Soul Food Festival
Designer John Sayles
(opposite)
Design Firm **Sayles Graphic Design**
Client Boneapatreat
Designer John Sayles

1.

2.

3.

4.

5.

6.

7.

1 - 7
Design Firm **Sayles Graphic Design**
1.
Client Go With the Flow Plumbing
Designer John Sayles
2.
Client House of Bricks Bar and Grill
Designer John Sayles
3.
Client Integrated Massage Therapy
Designer John Sayles
4.
Client Java B Good
Designer John Sayles
5.
Client Kirke Financial "Fudge Puppy"
Designer John Sayles
6.
Client Sloan Brothers Painting
Designer John Sayles

7.
Client LogoMotive
Designer John Sayles
(opposite)
Design Firm **Fifth Letter**
Client Wake Forest University
Designer Elliot Strunk

1.

2.

3.

4.

5.

6.

7.

8.

9.

10.

11.

12.

13.

14.

15.

1 - 15		
Design Firm	**Sayles Graphic Design**	
1.		
Client	P.E.O.	
Designer	John Sayles	
2.		
Client	People's	
Designer	John Sayles	
3.		
Client	Perky Parrot Coffee Shop	
Designer	John Sayles	
4.		
Client	Pine Ridge Farms	
Designer	John Sayles	
5.		
Client	PT Service	
Designer	John Sayles	
6.		
Client	Quarter Block	
Designer	John Sayles	
7.		
Client	Red Nose Lighting	
Designer	John Sayles	

8.	
Client	Rhino Materials
Designer	John Sayles
9.	
Client	Road to Ruin band
Designer	John Sayles
10.	
Client	Sexicide
Designer	John Sayles
11.	
Client	The Killjoys
Designer	John Sayles
12.	
Client	Tom Brien's Snak Mix
Designer	John Sayles
13.	
Client	Tonic
Designer	John Sayles
14.	
Client	Timber Valley
Designer	John Sayles
15.	
Client	Zook's Harley Davidson Route 65
Designer	John Sayles

1.

2.

3.

4.

5.

6.

7.

1 - 6
Design Firm **Sayles Graphic Design**
7
Design Firm **Zygo Communications**
1.
Client Wildwood Hills Ranch
Designer John Sayles
2.
Client With Pizzazz
Designer John Sayles
3 - 6.
Client Rathbun Marina
Designer John Sayles
7.
Client Full Contact Bowling
Designer Scott Laserow

(opposite)
Design Firm **Fifth Letter**
Client AIGA Raleigh
Designer Elliot Strunk

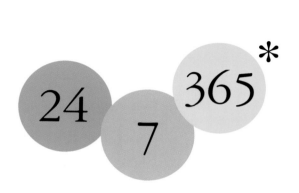

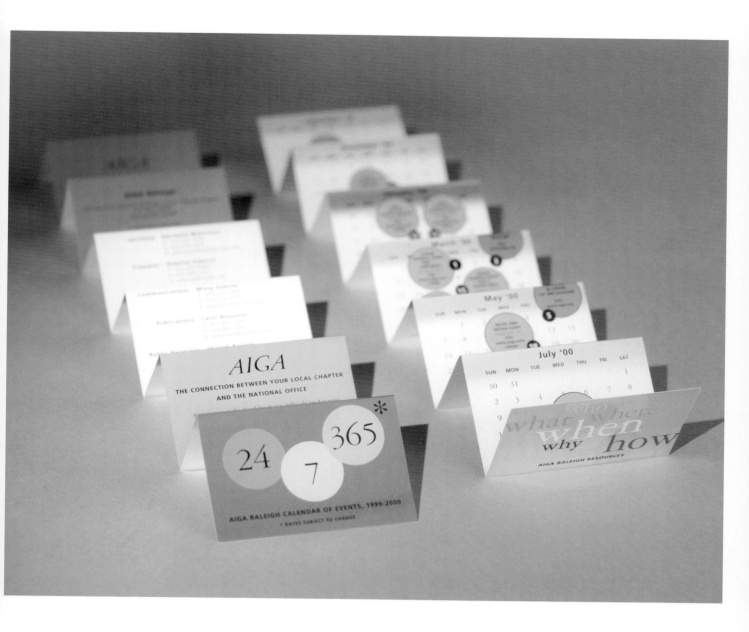

jobster

1.

MetricsDirect ™

2.

RIVERPLACE

3.

 urban**mobility**group

4.

SΘVA RCHITECTURE

5.

CitationShares

6.

7.

1 - 6
Design Firm **Hornall Anderson Design Works LLC**

7
Design Firm **Sayles Graphic Design**

1.
Client Jobster
Designers Jack Anderson, Michael Conners,
 Leo Raymundo

2.
Client MetricsDirect
Designers John Anicker, James Tee,
 Elmer dela Cruz, Kris Delaney

3.
Client RiverPlace
Designers Lisa Cerveny, Mary Hermes,
 Holly Craven, Andrew Wicklund,
 Elmer dela Cruz

4.
Client Urban Mobility Group
Designers Jana Nishi, Henry Yiu,
 Belinda Bowling

5.
Client SOV Architecture
Designers Jack Anderson, Larry Anderson,
 Henry Yiu

6.
Client CitationShares
Designers Jack Anderson, Kathy Saito,
 Henry Yiu, Elmer dela Cruz,
 Bruce Branson-Meyer,
 Alan Copeland

7.
Client Knoxville Chamber of Commerce
Designer John Sayles
(opposite)
Design Firm **Rickabaugh Graphics**
Client Marquette University
Designer Dave Cap

1.

Powering the Process of Invention

2.

3.

4.

5.

6. lil' puss®

7. chirp®

8. squirm®

9. wart®

10. slo poke®

11. mousy®

12. ruff®

1 - 3
Design Firm **StudioMoon / San Francisco**
4 - 12
Design Firm **Sayles Graphic Design**
1.
Client Doug Hiemstra,
 Hiemstra Product Development/SF
Designer Tracy Moon
2.
Client MDL Information Systems
Designer Tracy Moon
3.
Client Richard Nolan, M.D.
Designer Tracy Moon
4.
Client IShopDesMoines
Designer John Sayles
5.
Client Iowa Events Center
Designer John Sayles

6 - 12.
Client Lil' Puss & Friends
Designer John Sayles

1.

2.

3.

4.

5.

6.

7.

1 - 7
Design Firm **Rickabaugh Graphics**
1.
Client Minor League Baseball
Designer Eric Rickabaugh
2.
Client NAADD
Designer Eric Rickabaugh
3, 4.
Client North Carolina State
Designers Dave Cap, Eric Rickabaugh
5.
Client NFL
Designer Dave Cap
6.
Client NFL
Designer Eric Rickabaugh

7.
Client Ohio Dominican
Designers Eric Rickabaugh, Dave Cap
(opposite)
Design Firm **Hornall Anderson Design Works LLC**
Client Widmer Brothers Brewery
Designers Jack Anderson, Larry Anderson, Jay Hilburn, Bruce Stigler, Elmer dela Cruz, Daymon Bruck, Hayden Schoen

1.

2.

3.

4.

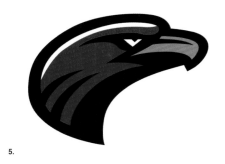

5.

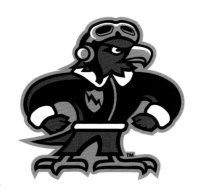

6.

7.

1 - 7
Design Firm **Rickabaugh Graphics**
1.
Client Oklahoma State University
Designer Eric Rickabaugh
2, 3.
Client Ohio State
Designer Eric Rickabaugh
4 - 6.
Client University of Louisiana Monroe
Designer Dave Cap

7.
Client The Textile Foundation
Designer Eric Rickabaugh
(opposite)
Design Firm **Dragon Rouge**

1.

2.

3.

4.

5.

6.

7.

8.

9.

10.

11.

12.

13.

14.

15.

1 - 15
Design Firm **Rickabaugh Graphics**
1, 2, 9, 10.
Client Ohio State
Designer Dave Cap
3.
Client Project Foundry
Designer Eric Rickabaugh
4.
Client Race 4 Animals
Designer Eric Rickabaugh
5, 6.
Client Toyota/Saatchi + Saatchi
Designer Dave Cap
7, 8.
Client University of West Georgia
Designer Dave Cap
11.
Client Robert Morris University
Designer Dave Cap
12.
Client Seton Hall University
Designer Dave Cap

13.
Client Tennessee Tech
Designers Eric Rickabaugh, Dave Cap
14.
Client Texas A&M/Texas
Designers Eric Rickabaugh, Dave Cap
15.
Client University of South Dakota
Designer Dave Cap

1.

2.

interaktiv

3.

50CIAL
AIGA CHATTANOOGA EVENTS CALENDAR

4.

THE FOUR SEVENTEEN
ON FRAZIER

5.

6.

THE
ACCOUNTABILITY
COMPANY

7.

8.

9.

AUSTIN/DEVELOPMENT/GROUP

10.

11.

GOLF CLUB
BIG SANDY
established 1969

12.

13.

★
CAPITALMARK
BANK & TRUST

14.

15.

1.

2.

3.

4.

5.

6.

7.

and along came baby

1.

PLANNING ■ ■ ■
ARCHITECTURE ■ ■ ■

api

2.

CARROLL & ASSOCIATES, LLP

3.

CENTER
STAGE

4.

CRIVELLI
INSURANCE SERVICES

5.

MODESTO
DID
DOWNTOWN
IMPROVEMENT DISTRICT

6.

htc howard training center

7.

1 - 7
Design Firm **Never Boring Design Associates**
1.
Client And Along Came Baby
Designer Julie Orona
2.
Client API
Designer Shawna Bayers
3.
Client Carrol & Associates
Designer Julie Orona
4.
Client Canter Stage
Designer Shawna Bayers
5.
Client Crivelli Insurance Services
Designer Julie Orona

6.
Client Modesto Downtown
 Improvement District
Designer Julie Orona
7.
Client Howard Training Center
Designer Katrina Furton
(opposite)
Design Firm **Dragon Rouge**

1.

kidlands
furniture emporium

2.

mercerfoods

3.

NATIONAL
funding group

4.

simon yakligian dds
Family & Cosmetic Dental Care

5.

PH**O**ENIX
BATTLEGROUNDS

6.

MODESTO
SAND AND GRAVEL
DEMOLITION & EXCAVATION

7.

nirvana

8.

9.

10.

monte vista
CHAPEL

11.

PASO PACÍFICO

*Making connections
for conservation*

12.

PARAGONDENTAL

13.

ROSS F. CARROLL, INC.
General Engineering Contractor

14.

KLA

LANDSCAPE
ARCHITECTURE
PLANNING

15.

1 - 15		
Design Firm	**Never Boring Design Associates**	
1.		
Client	Modesto Nuts	
Designer	Katrina Furton	
2.		
Client	Kidlands Furniture Emporium	
Designers	Shawna Bayers, David Boring	
3.		
Client	Mercer Foods	
Designer	Shawn Branstetter	
4.		
Client	National Funding Group	
Designer	Katrina Furton	
5.		
Client	Simon Yakligian	
Designer	Shawn Branstetter	
6.		
Client	Phoenix Battlegrounds	
Designer	Shawn Branstetter	
7.		
Client	Modesto Sand and Gravel	
Designer	Shawn Branstetter	

8.	
Client	Nirvana
Designer	Julie Orona
9.	
Client	Western Group
Designer	Julie Orona
10.	
Client	Never Boring Design Associates
Designer	David Boring
11.	
Client	Monte Vista Chapel
Designer	Shawna Bayers
12.	
Client	Paso Pacifico
Designer	Shawn Branstetter
13.	
Client	Paragon Dental
Designer	Katrina Furton
14.	
Client	Ross F. Carroll
Designer	Julie Orona
15.	
Client	KLA
Designers	Katrina Furton, Julie Orona

1.

2.

3.

4.

5.

6.

7.

1 - 6
Design Firm **Never Boring Design Associates**
7
Design Firm **elf design, inc.**

1.
Client River Lights Chorus
Designer Julie Orona

2.
Client Sharp Advantage
Designer Julie Orona

3.
Client Sterling Home Showcase
Designer Katrina Furton

4.
Client Stewart Chiropractic
Designer Katrina Furton

5.
Client Tasty Taco
Designer Katrina Furton

6.
Client Stoll Appraisals
Designer Julie Orona

7.
Client Beadjoux by Shelley Bond
Designer Erin Ferree

(opposite)
Design Firm **Studio International**
Client Zagrebacki velesajam / Zagreb Fair
Designer Boris Ljubicic

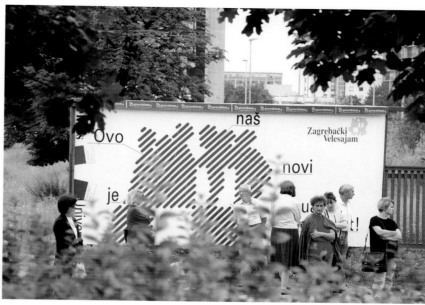
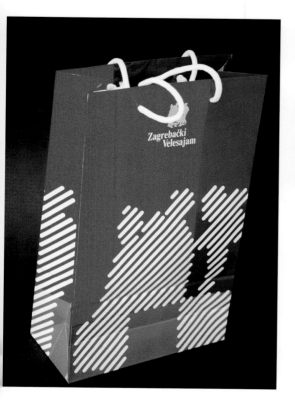
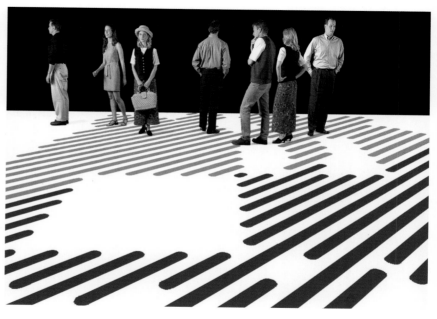

1.

2.

3.

4.

5.

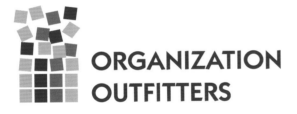

6.

7.

1 - 7
Design Firm **elf design, inc.**
1.
Client ABNDesign Ltd.
Designer Erin Ferree
2.
Client Absolutely, Inc.
Designer Erin Ferree
3.
Client Bow Wow Bootcamp
Designer Erin Ferree
4.
Client Chenoo
Designer Erin Ferree
5.
Client Crescenda Coaching
Designer Erin Ferree

6.
Client Coyote Ridge Ranch
Designer Erin Ferree
7.
Client Organization Outfitters
Designer Erin Ferree
(opposite)
Design Firm **Kenneth Diseño**
Client Sunset Snack Bar
Designer Kenneth Treviño

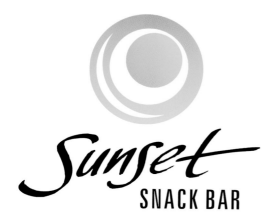

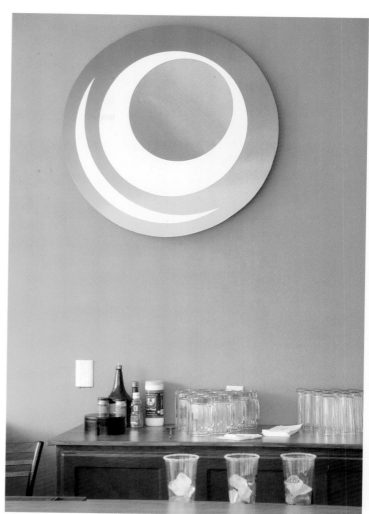

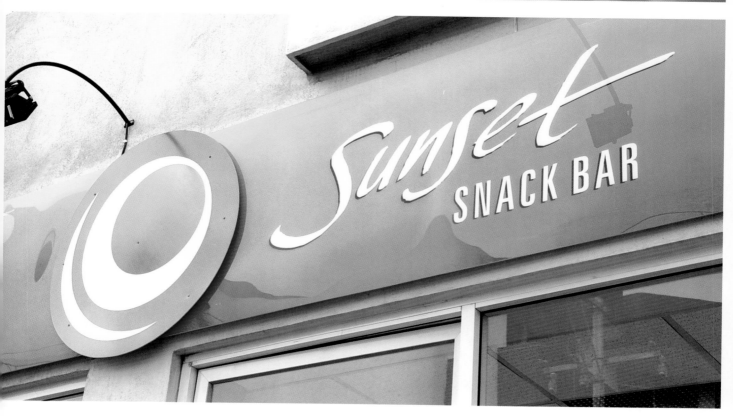

1.

EGRESS

2.

FunGrandma

3.

GeoPoint
RESEARCH SYSTEMS

4.

Ginger &
Peppermint

5.

Good
Elements

6.

HAMADY
CHIROPRACTIC CENTER

7.

Have Wax,
Will Travel

8.

Legal Aid Association
of California

9.

Leadersearch

10.

11.

12.

13.

14.

15.

1 - 15
Design Firm **elf design, inc.**

1.
| Client | Dropwise Essentials |
| Designer | Erin Ferree |

2.
| Client | Egress |
| Designer | Erin Ferree |

3.
| Client | Fun Grandma |
| Designer | Erin Ferree |

4.
| Client | GeoPoint Research Systems |
| Designer | Erin Ferree |

5.
| Client | Ginger & Peppermint |
| Designer | Erin Ferree |

6.
| Client | Good Elements |
| Designer | Erin Ferree |

7.
| Client | Hamady Chiropractic Center |
| Designer | Erin Ferree |

8.
| Client | Have Wax, Will Travel |
| Designer | Erin Ferree |

9.
| Client | Legal Aid Association of California |
| Designer | Erin Ferree |

10.
| Client | Leadersearch, Inc. |
| Designer | Erin Ferree |

11.
| Client | Luvelle |
| Designer | Erin Ferree |

12.
| Client | Ms. Clutter Buster |
| Designer | Erin Ferree |

13.
| Client | On the Marx Acupuncture |
| Designer | Erin Ferree |

14.
| Client | Paradise Valley Spas |
| Designer | Erin Ferree |

15.
| Client | Perfect Path |
| Designer | Erin Ferree |

1.

2.

3.

4.

5.

MPC SPEED

6.

7.

1 - 5
　Design Firm **Master Design Los Angeles**
6
　Design Firm **Creative Vision Design Co.**
7
　Design Firm **Studio International**
1.
　Client　　　Karen Nelson Bell
　Designer　Dali Bahat
2.
　Client　　　Mr. Craig Jensen
　Designer　Dali Bahat
3.
　Client　　　Hoffman Educational Systems
　Designer　Dali Bahat
4.
　Client　　　Little Big Pie Native
　　　　　　　American Restaurants
　Designer　Dali Bahat
5.
　Client　　　Peacock Crafts
　Designer　Dali Bahat

6.
　Client　　　MPC Speed
　Designer　Greg Gonsalves
7.
　Client　　　Ministarstvo obrane Republike
　　　　　　　Hrvatske/Croatian Ministry of
　　　　　　　Defense
　Designer　Boris Ljubcic
(opposite)
　Design Firm **Truefaces Creation Sdn Bhd**
　Client　　　Edaran Otomobil Nasional Berhad
　Designer　Truefaces Creative Team

1.

SUBANG JAYA • SELANGOR

2.

3.

4.

5.

6.

TANIA T. TANYONG

7.

8.

9.

AIR MINUM

10.

11.

crecimiento con calidad

12.

HUERTAS
la ilusión

13.

14.

15.

1 - 11		
Design Firm	**Truefaces Creation Sdn Bhd**	
12 - 15		
Design Firm	**Kenneth Diseño**	
1.		
	Client	USJ5 Residents Association, Subang Jaya, Selangor
	Designers	Truefaces Creative Team
2 - 6.		
	Client	My-Turf Sdn Bhd
	Designers	Truefaces Creative Team
7.		
	Client	Synchrony Gateway Sdn Bhd
	Designers	Truefaces Creative Team
8.		
	Client	Your Friendly Entertainer Sdn Bhd
	Designers	Truefaces Creative Team
9.		
	Client	P.T. Holan Nika Permata, Indonesia
	Designers	Truefaces Creative Team
10.		
	Client	Figo Foods Sdn Bhd
	Designers	Truefaces Creative Team
11.		
	Client	Tranquiltech Sdn Bhd
	Designers	Truefaces Creative Team
12.		
	Client	Crezco Program
	Designer	Kenneth Treviño
13.		
	Client	La Ilusión avocado orchards
	Designer	Kenneth Treviño
14.		
	Client	Dennis Pizza
	Designer	Kenneth Treviño
15.		
	Client	Solidarity Vineyards
	Designer	Kenneth Treviño

1.

2.

3.

4.

5.

6.

7.

8.

fairtrasa
INTERNATIONAL

9.

BODEGA
FURLOTTI

10.

ASOCIACION Ð FABRICANTES Ð
GUITARRAS
E INSTRUMENTOS Ð CUERDA A.C.

11.

INNOVACIÓN
DENTAL

12.

Kenneth
DISEÑO

13.

LA
CREACIÓN

14.

La Fontana
RISTORANTE

15.

1 - 15
Design Firm **Kenneth Diseño**
1.
Client 4x4
Designers Kenneth Treviño, Minerva Galván
2.
Client Aldamiel
Designer Kenneth Treviño
3.
Client Aquí Nomás
Designers Kenneth Treviño, Minerva Galván
4.
Client Codice Copier & Digital Printer Shop
Designer Kenneth Treviño
5.
Client Del Parque
Designer Kenneth Treviño
6.
Client Eco Memories
Designer Kenneth Treviño
7.
Client El Pedal
Designer Kenneth Treviño

8.
Client Exotic
Designer Kenneth Treviño
9.
Client Fair Trade South America
Designer Kenneth Treviño
10.
Client Furlotti Wine Cellars
Designer Kenneth Treviño
11.
Client Guitar Manufacturers Assoc.
Designers Kenneth Treviño, Minerva Galvan
12.
Client Innovación Dental
Designer Kenneth Treviño
13.
Client Kenneth Diseño
Designer Kenneth Treviño
14.
Client La Creación
Designer Kenneth Treviño
15.
Client La Fontana
Designer Kenneth Treviño

1.

Samoa

2.

Samoa

3.

Schmidt **electric**

4.

TYPE SYNC

5.

mindfluence

6.

PEPE
THE BEST RADIO STATATION

7.

1 - 7
Design Firm **typesync studio**
1.
 Client Network Telecommunication System
 Designer Anastasia Bogdanova
2, 3.
 Client Samoa
 Designer Anastasia Bogdanova
4.
 Client Schmidt Electric
 Designer Anastasia Bogdanova
5.
 Client typesync studio
 Designer Anastasia Bogdanova
6.
 Client mindfluence
 Designer Anastasia Bogdanova

7.
 Client PEPE
 Designer Anastasia Bogdanova
(opposite)
 Design Firm **Hornall Anderson
 Design Works LLC**
 Client Virtutech
 Designers Daymon Bruck, Yuri Shvets

TERESIANUM

1.

2.

NO!SPEC
no-spec.com

3.

YELLOW JERSEYS
C O N S U L T A N C Y
Limited

4.

ROSEMARY FIELDS
L I M I T E D

5.

Satori
G A R D E N N U R S E R Y

6.

Olstein

7.

1
 Design Firm **Kenneth Diseño**
2 - 6
 Design Firm **ArtnSoul Graphic Design**
7
 Design Firm **Langton Cherubino Group, Ltd.**
1.
 Client Teresianum
 Designer Kenneth Treviño
2.
 Client ArtnSoul Graphic Design
 Designer Piers Le Sueur
3.
 Client no-spec.com
 Designer Piers Le Sueur
4.
 Client Yellow Jerseys Consulting Limited
 Designer Piers Le Sueur

5.
 Client Rosemary Fields Ltd
 Designer Piers Le Sueur
6.
 Client Satori Garden Nursery
 Designer Piers Le Sueur
7.
 Client Olstein Capital Management, L.P.
 Designer Jim Keller
(opposite)
 Design Firm **Flowdesign, Inc.**
 Client Mountain Valley Spring Company
 Designers Dan Matauch, Dennis Nalezyty

1.

2.

3.

4.

5.

6.

7.

8.

9.

10.

11.

SUMMERTIME, AND THE LEARNING IS EASY.

12.

13.

CENTER
for Meeting & Learning

14.

15.

1 - 15
Design Firm **Funk/Levis & Associates**

1.
| Client | Advantage Oregon, Inc. |
| Designer | Claudia Villegas |

2.
| Client | Cascade Consulting Partners |
| Designer | Lada Korol |

3.
| Client | Color of Beauty Tanning Salon |
| Designer | Lada Korol |

4.
| Client | Community Health Centers of Lane County |
| Designer | Claudia Villegas |

5.
| Client | Downtown English |
| Designers | David Funk, Claudia Villegas |

6.
| Client | Downtown Eugene |
| Designer | Claudia Villegas |

7.
| Client | Fisher Farms |
| Designer | Bev Soasey |

8.
| Client | Imagine Graphics |
| Designers | Claudia Villegas, Chris Berner |

9.
| Client | Junior League |
| Designer | Claudia Villegas |

10.
| Client | KLCC |
| Designer | Claudia Villegas |

11, 12.
| Client | Lane Community College |
| Designer | Lada Korol |

13.
| Client | Lane Community College |
| Designer | Lada Korol, Claudia Villegas |

14.
| Client | Lane Community College |
| Designer | Claudia Villegas |

15.
| Client | Lane County Waste Management |
| Designers | Lada Korol, Chris Berner |

1.

National Warranty Corporation

2.

Native Forest COUNCIL

Life, Land & Liberty

3.

NEWTON LEARNING

75th ANNIVERSARY

OREGON ASSOCIATION OF NURSERIES

4.

5.

Le Tour des Plants

A Garden Center Excursion

OREGON ASSOCIATION OF NURSERIES

6.

OregonGrown℠

7.

ONELINK CORPORATION

8.

9.

10.

11.

12.

13.

Seasons

14.

15.

1 - 15
Design Firm **Funk/Levis & Associates**

1.
Client National Warranty Corporation
Designer Claudia Villegas

2.
Client Native Forest Council
Designer David Funk

3.
Client Newton Learning
Designer Chris Berner

4, 5.
Client Oregon Association of Nurseries
Designer Claudia Villegas

6, 7.
Client Oregon Association of Nurseries
Designer Chris Berner

8.
Client One Link Corporation
Designers Claudia Villegas, Bev Soasey

9.
Client OZ World Construction Landscaping
Designer Chris Berner

10.
Client PacificSourse
Designer Lada Korol

11.
Client Phoenix Residential Care
Designer Lada Korol

12.
Client Red Tractor Landscaping
Designer Claudia Villegas

13.
Client Salem Hospital
Designer Lada Korol

14.
Client Seasons Restaurant
Designers Chris Berner

15.
Client SevenOaks Business Park
Designers Chris Berner

SEVENTH
MOUNTAIN
RESORT

1.

2.

3.

SUSTAINABLE
Business Initiative Task Force

4.

5.

6.

ALL ROADS LEAD TO THE GROVE

Busch's Grove

EST. 1890

7.

1 - 5
Design Firm **Funk/Levis & Associates**
6, 7
Design Firm **TOKY Branding + Design**

1.
Client Seventh Mountain Resort
Designer Chris Berner

2.
Client Shelter Care
Designers Alex Wijnen, Lada Korol

3.
Client SummerOaks Business Park
Designers Chris Berner, Bev Soasey

4.
Client Sustainable Business Initiative
Designer Claudia Villegas

5.
Client Wyeast Laboratories
Designer Bev Soasey

6.
Client Aura Renewable Energy
 Corporation
Designers Benjamin Franklin, Eric Thoelke

7.
Client Busch's Grove
Designers Katy Fischer, Eric Thoelke
(opposite)
Design Firm **Dragon Rouge**

1.

2.

3.

4.

5.

6.

7.

8.

9.

10.

11.

12.

BUTLER'S PANTRY

13.

15.

OAKWOOD

14.

SPEAK THEIR LANGUAGE®

1.

SPEAK THEIR LANGUAGE®

2.

SPEAK THEIR LANGUAGE®

3.

SPEAK THEIR LANGUAGE®

4.

5.

HILL INVESTMENT GROUP

Take the long view

6.

7.

1 - 7
Design Firm **TOKY Branding + Design**
1 - 4.
 Client Dialect®
 Designer Eric Thoelke
5.
 Client Grand Center™
 Designer Eric Thoelke
6.
 Client Hill Investment Group
 Designers Benjamin Franklin, Eric Thoelke,
 Steven Noble
7.
 Client Kassel & Iron™
 Designers Tara Pederson, Eric Thoelke

(opposite)
Design Firm **Studio International**
Client Ministarstvo KultureRH/Ministry of
 Culture og Croatia
Designer Boris Ljubicic

176

*Republic
of Croatia
Ministry
of Culture*
Republika
Hrvatska
Ministarstvo
kulture

1.

2.

3.

4.

5.

6.

7.

1 - 7
Design Firm **Master Design Los Angeles**
1.
Client Bien Sport Inc.
Designer Dali Bahat
2.
Client The Art Book
Designer Dali Bahat
3.
Client Ocean Breeze Air Conditioning Inc.
Designer Dali Bahat
4.
Client Data Retrieval Services, Inc.
Designer Dali Bahat
5.
Client Del David Foods, Inc.
Designer Dali Bahat
6.
Client Rainbow Gallery, Inc.
Designer Dali Bahat

7.
Client Watch Dog Security Systems, Inc.
Designer Dali Bahat
(**opposite**)
Design Firm **Enterprise IG, Johannesburg**
Client RMMM
Designers Dave Holland, Adam Botha

ROUTLEDGE
MODISE
MOSS ATTORNEYS
MORRIS

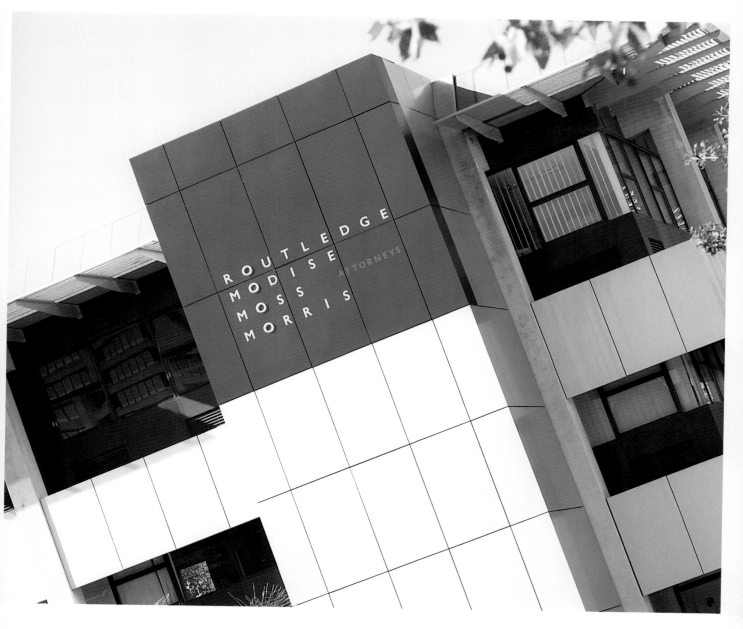

1.

2.

3.

4.

5.

6.

7.

8.

9.

10.

11.

12.

13.

THE AVENG GROUP

14.

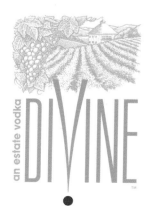

15.

1 - 14
Design Firm **Enterprise IG, Johannesburg**

15
Design Firm **Flowdesign, Inc.**

1.
Client — Guarantee Trust Bank
Designers — Collette Wasilewski, Iaan Becker

2.
Client — Kapci Coatings
Designer — Leoni Watson

3.
Client — Agrinet/Landmark
Designer — Dave Holland

4.
Client — Moolmans Opencast Mining
Designers — Simon Francis, Dave Holland

5.
Client — Rogers Group
Designer — Dave Holland

6.
Client — Skye Bank
Designer — Dave Holland

7.
Client — The South African Ballet Theatre
Designer — Beverly Field

8.
Client — Trend TV
Designers — Adam Botha, Dave Holland

9.
Client — Transvaal Suiker Beperk
Designer — Robert du Toit

10.
Client — ZB Financial Holdings
Designer — Dave Holland

11.
Client — Neotel
Designer — Adam Botha

12.
Client — De Beers,
The Diamond Birding Route
Designer — Bronwen Rautenbach

13.
Client — Diamond Bank, Nigeria
Designer — Bronwen Rautenbach

14.
Client — The Aveng Group
Designer — Bronwen Rautenbach

15.
Client — Divine Vodka
Designers — Dan Matauch, Dennis Nalezyty

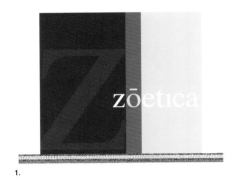

1.

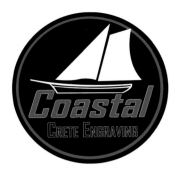

2.

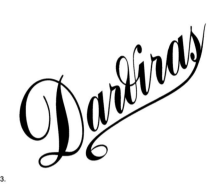

3.

4.

5.

VERSA•TAGS

6.

VERSA•TAGS

7.

1
 Design Firm **McKnight Kurland Baccelli**
2
 Design Firm **JF GRAPHIC STUDIO**
3 - 5
 Design Firm **Will Winston Design**
6, 7
 Design Firm **Snap Creative**
1.
 Client Zoetica Spa
 Designers McKnight Kurland Baccelli
2.
 Client Coastal Crete Engraving
 Designer Janette Fernandes
3.
 Client Darviras Mandolins
 Designer Will Casserly
4.
 Client Edelman Financial Services LLC
 Designer Will Casserly

5.
 Client Free Spirits Women's
 Travel Basketball
 Designer Will Casserly
6, 7.
 Client Versatags
 Designer Angela Neal
(opposite)
 Design Firm **NBC Universal Global**
 Networks Italia
 Client NBC Universal Global Networks
 Designer Giovanni Staccone

1.

2.

3.

MONARCH
LIFE BALANCE
Having it all, making it work

4.

5.

TLConsulting
DRIVING ORGANIZATIONAL CHANGE

6.

7.

1 - 7
Design Firm **Snap Creative**

1.
Client Micrologic
Designers Angela Neal, Sarah E.G. Waters

2.
Client Environmental Management Alternatives
Designers Angela Neal, Sarah E.G. Waters

3.
Client JUST Building and Remodeling
Designers Angela Neal, Hilary Clements

4.
Client Monarch Life Balance
Designer Angela Neal

5.
Client Midwest Industrial
Designer Angela Neal

6.
Client TLC Consulting
Designers Angela Neal, Sarah E.G. Waters

7.
Client Sayers Design, Inc.
Designers Angela Neal, Hilary Clements

(opposite)
Design Firm **Hornall Anderson Design Works LLC**
Client Clearwire
Designers Jack Anderson, John Anicker, Leo Raymundo, Sonja Max, Andrew Wicklund

1.

2.

3.

4.

5.

6.

7.

8.

9.

10.

11.

12.

13.

FRECCIA STUDIOS

FINE DECORATIVE ARTS

14.

Heathcote *Tavern*

15.

1 - 12
Design Firm **Truefaces Creation Sdn Bhd**
13 - 15
Design Firm **StudioMoon / San Francisco**

1.
Client Arena Mainan Keluarga
Designers Truefaces Creative Team

2, 3.
Client Fortitude Marketing Sdn Bhd
Designers Truefaces Creative Team

4.
Client Heart Connection
Designers Truefaces Creative Team

5.
Client HML Auto Industries Sdn Bhd
Designers Truefaces Creative Team

6.
Client Department of Agriculture Malaysia
Designers Truefaces Creative Team

7.
Client Edaran Otomobil Nasional Berhad
Designers Truefaces Creative Team

8, 9.
Client Sime UEP Properties Sdn Bhd
Designers Truefaces Creative Team

10.
Client One Goods
Designers Truefaces Creative Team

11.
Client Rent.A.Port Landscape Sdn Bhd
Designers Truefaces Creative Team

12.
Client Southern Bank Berhad
Designers Truefaces Creative Team

13.
Client Carol McCutcheon Aguilar
Designer Tracy Moon

14.
Client Tobias Freccia, Freccia Studios
Designer Tracy Moon

15.
Client Tony Fortuna/New York
Designer Tracy Moon

1.

2.

3.

R.M. BINNEY architects

4.

5.

W.
Newton Auto Service, Inc.

6.

valenite
N TE
with a stars

7.

1 - 7
Design Firm **typesync studio**
1.
Client west east
Designer Anastasia Bogdanova
2.
Client Wave Marketing
Designer Anastasia Bogdanova
3.
Client Youth Dance Culture
Designer Anastasia Bogdanova
4.
Client R.M. Binney Architects
Designer Anastasia Bogdanova
5.
Client Play More Toy Store
Designer Anastasia Bogdanova
6.
Client West Newton Auto Service
Designer Anastasia Bogdanova

7.
Client Valenite
Designer Anastasia Bogdanova
(opposite)
Design Firm **Hornall Anderson
 Design Works LLC**
Client Enertech
Designers Jack Anderson, James Tee,
 Beth Grimm, Elmer dela Cruz,
 Sonja Max, Lauren DiRusso

1.

2.

3.

4.

5.

6.

Visual Branding | Corporate Identity

ROSEBRUCE
graphics & design

7.

1 - 4
Design Firm **typesync studio**
5 - 7
Design Firm **Rose Bruce Graphics & Design**
1.
Client Tele Cube
Designer Anastasia Bogdanova
2.
Client X co.
Designer Anastasia Bogdanova
3.
Client citron
Designer Anastasia Bogdanova
4.
Client cbt architects
Designer Anastasia Bogdanova
5.
Client Joi Medspa
Designer Rose Bruce

6.
Client The Cassetty Team
Designer Rose Bruce
7.
Client Rose Bruce Graphics & Design
Designer Rose Bruce
(opposite)
Design Firm **Sayles Graphic Design**
Client maDIKwe
Designer John Sayles

1.

2.

3.

4.

5.

6.

7.

8.

9.

10.

11.

12.

13.

14.

15.

1 - 15
Design Firm **Kenneth Diseño**

1.
Client Ledesma
Designer Kenneth Treviño

2.
Client llamales.com
Designer Kenneth Treviño

3.
Client Luthier
Designers Kenneth Treviño, Minerva Galván

4.
Client Fresh Directions International
Designer Kenneth Treviño

5.
Client Mexavito
Designer Kenneth Treviño

6.
Client Moon Light
Designer Kenneth Treviño

7.
Client Mr. Costillas Restaurant
Designer Kenneth Treviño

8.
Client Planteca
Designer Kenneth Treviño

9.
Client Pollo Carretas
Designer Kenneth Treviño

10.
Client Radio Comunicaciones de Uruapan
Designers Kenneth Treviño, Minerva Galván

11.
Client Riyitos
Designer Kenneth Treviño

12.
Client Solazul
Designer Kenneth Treviño

13.
Client Soluna Wines
Designer Kenneth Treviño

14.
Client Suavo Avocados
Designer Kenneth Treviño

15.
Client Texas BBQ
Designer Kenneth Treviño

1.

2.

3.

4.

5.

6.

7.

1 - 7
Design Firm **Creative Vision Design Co.**
1.
Client Peregrine Group
Designer Greg Gonsalves
2.
Client Buntz Farm
Designer Greg Gonsalves
3.
Client Capri
Designer Greg Gonsalves
4.
Client Piscopio Properties
Designer Greg Gonsalves
5.
Client Up Country
Designer Greg Gonsalves
6.
Client TwistCo.
Designer Greg Gonsalves

7.
Client West Shore Dental Associates
Designer Greg Gonsalves
(opposite)
Design Firm **Sermi**
Client NBC Universal Global Networks
Designers Sermi

194

1.

2.

3.

4.

5.

6.

7.

1 - 3
Design Firm **TOKY Branding + Design**
4 - 7
Design Firm **Studio International**
1.
 Client Rooster
 Designers Jamie Banks George, Eric Thoelke
2.
 Client Observable Books
 Designers Benjamin Franklin, Eric Thoelke
3.
 Client Regional Arts Commission
 of St. Louis™
 Designer Eric Thoelke
4.
 Client Mljet National Park
 Designer Boris Ljubicic
5.
 Client Music Biennale Zagreb
 Designer Boris Ljubicic

6.
 Client Optima telecom
 Designer Boris Ljubicic
7.
 Client Spectator Group
 Designer Boris Ljubicic
(**opposite**)
 Design Firm **Truefaces Creation Sdn Bhd**
 Client Wearone
 Designers Truefaces Creative Team

1.

2.

3.

4.

5.

6.

7.

8.

9.

10.

11.

12.

13.

14.

15.

1 - 7
Design Firm **Maycreate**
8 - 10
Design Firm **Dragon Rouge**
11 - 15
Design Firm **StudioMoon / San Francisco**

1.
Client Marlin Outlets
Designer Brian May
2.
Client Ringgold Telephone Service
Designer Brian May
3.
Client Preservation Studio South
Designer Brian May
4.
Client Dan Rayburn
Designer Brian May
5.
Client Scene12
Designer Brian May
6.
Client Smartech
Designer Brian May

7.
Client st3.com
Designer Brian May
8 - 10.
Designer Dragon Rouge
11.
Client Diana Randle, Blue Cat Studios
Designer Tracy Moon
12.
Client Ken Viale
 Photography/San Francisco
Designer Tracy Moon
13.
Client Rothschild, Patient Comfort Systems
Designer Tracy Moon
14.
Client K.D. Sullivan/Creative Solutions,
 San Francisco
Designer Tracy Moon
15.
Client Joseph Staniford,
 Oso Loco Vineyards
Designers Scott Bevan, Tracy Moon

1.

2.

3.

4.

5.

6.

7.

8.

9.

10.

11.

12.

13.

14.

15.

1 - 15
Design Firm **Maycreate**

1.
Client Sweet Treats Cotton Candy
Designers Brian May, Paul Rustand

2.
Client Jordan Drug
Designer Brian May

3.
Client Jean Taylor Folk Art
Designer Brian May

4.
Client Mammoth Data
Designer Brian May

5.
Client The Marlin Group
Designer Brian May

6.
Client Marlin Health
Designer Brian May

7.
Client Marlin Studios
Designer Brian May

8.
Client Maycreate
Designer Brian May

9.
Client MicroWireless
Designer Zon Carvalho

10.
Client Midtown Music Hall
Designer Brian May

11.
Client Marlin Central Monitoring
Designer Grant Little

12.
Client Nature's Complete
Designer Brian May

13.
Client WV Fiber
Designer Brian May

14.
Client Nextlec Broadband Solutions
Designer Brian May

15.
Client North Cliffe Baptist Church
Designer Brian May

30 YEARS OF METAL

1.

2.

©HUCK ©ROWDER

3.

EMBELLISH

4.

MARLIN
e SOURCING
SOLUTIONS

5.

FA
FIRSTASSURANCE
"Property Inventory Specialist"

6.

7.

the fellowship

8.

9.

GatewayMarkets

10.

Harmony
PRODUCTS
Man and Nature

11.

HeadsUp
entertainment

12.

IBIS7 NETWORKS

13.

14.

NO SPEED LIMITS
Inet75

15.

1 - 15
Design Firm **Maycreate**

1.
Client — Clifton May
Designer — Brian May

2.
Client — Core Painting
Designer — Brian May

3.
Client — Chuck Crowder (copywriter)
Designer — Brian May

4.
Client — Embellish Shoes
Designers — Brian May, Rodney Simmons

5.
Client — Marlin Sourcing
Designer — Brian May

6.
Client — First Assurance
Designer — Brian May

7.
Client — FedUps
Designer — Brian May

8.
Client — Signal Mountain Presbyterian Church
Designer — Brian May

9.
Client — East Tennessee Presbytery
Designer — Brian May

10.
Client — Gateway Markets
Designer — Brian May

11.
Client — Harmony Products
Designers — Brian May, Will Adams

12.
Client — Heads Up Entertainment
Designer — Brian May

13.
Client — Ibis7 Networks
Designer — Brian May

14.
Client — Inner Circle Club of Augusta
Designer — Brad Dicharry

15.
Client — NextLec
Designer — Brian May

1.

2.

3.

INTERNATIONAL SPORTS HERITAGE ASSOCIATION

4.

5.

6.

7.

1 - 7
Design Firm **Rickabaugh Graphics**

1 - 3.
Client Texas A&M
Designers Dave Cap, Eric Rickabaugh

4.
Client ISHA
Designer Eric Rickabaugh

5.
Client Luckie & Co./McKee Foods
Designer Eric Rickabaugh

6.
Client SRA
Designer Eric Rickabaugh

7.
Client MEAC
Designer Eric Rickabaugh

(opposite)
Design Firm **StudioMoon / San Francisco**
Client Adelante Capital Management
Designer Tracy Moon

ADELANTE

Capital Management®

1.

2.

3.

4.

5.

6.

7.

1 - 7
Design Firm **Rickabaugh Graphics**
1.
Client ICLA
Designer Eric Rickabaugh
2, 3.
Client ICLA
Designer Dave Cap
4.
Client Huntington Banks
Designer Dave Cap
5.
Client Phil Hellmuth
Designers Eric Rickabaugh, Dave Pena
6.
Client Hasbro, Inc.
Designer Dave Cap

7.
Client Georgia Southern
Designer Eric Rickabaugh
(opposite)
Design Firm **Studio International**
Client Ministarstvo unutarnjih poslova
 Hrvatskel/Ministry of
 Foreign Affairs Croatia
Designer Boris Ljubicic

1.

2.

3.

4.

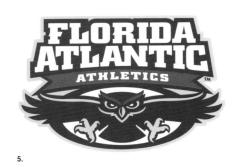

5.

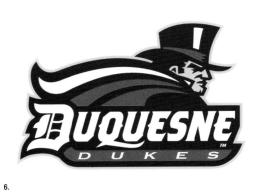

6.

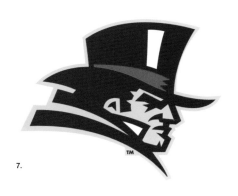

7.

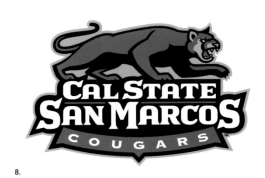

8.

9.

10.

11.

12.

13.

14.

15.

1 - 15
Design Firm **Rickabaugh Graphics**
1.
 Client Florida A&M
 Designers Dave Cap, Eric Rickabaugh
2.
 Client Gameday
 Designer Eric Rickabaugh
3.
 Client Fresno Pacific
 Designer Eric Rickabaugh
4, 5.
 Client Florida Atlantic University
 Designer Eric Rickabaugh
6, 7.
 Client Duquesne University
 Designers Eric Rickabaugh, Dave Cap
8.
 Client Cal State—San Marcos
 Designer Dave Cap
9.
 Client City of Columbus
 Designer Dave Cap

10.
 Client Coca-Cola
 Designer Eric Rickabaugh
11.
 Client Clorox Inc.
 Designer Dave Cap
12.
 Client University of Cincinnati
 Designer Eric Rickabaugh
13, 14.
 Client Ball Hawg
 Designer Dave Cap
15.
 Client Berlin 4Hers
 Designer Eric Rickabaugh

1.

2.

3.

4.

5.

6.

7.

8.

9.

FLYING PENGUIN
PICTURES

10.

N R P S L
NATIONAL ROCK · PAPER · SCISSORS LEAGUE

11.

JUMP
START

12.

Ekko
RESTAURANT

13.

Cultural Diversity In Business
EXPO

14.

GUERRILLA
TEAM
1
MARKETING

15.

1.

2.

3.

4.

5.

6.

7.

1 - 6
Design Firm **Stephen Longo Design Associates**
7
Design Firm **Octavo Designs**

1.
Client Media Consultants
Designer Stephen Longo

2.
Client AdLab
Designer Stephen Longo

3.
Client Oskar Schindler Performing Arts Center
Designer Stephen Longo

4.
Client The Hearing Group
Designer Stephen Longo

5.
Client The West Orange Arts Council
Designer Stephen Longo

6.
Client Woman's Physique
Designer Stephen Longo

7.
Client It's All About The Bride, LLC
Designers Sue Hough, Mark Burrier
(opposite)
Design Firm **It's a Go!**
Client Earth Products
Designers Heidie Kumpf, Glenda Venn

**Responsiveness:
The Fourth "R"**

1.

2.

3.

4.

5.

6.

7.

1 - 7
Design Firm **Octavo Designs**

1.
Client	National Association of School Psychologists
Designers	Sue Hough, Mark Burrier

2.
Client	WeInterpret.net
Designers	Sue Hough, Mark Burrier

3.
Client	Tauraso's Ristorante & Trattoria
Designers	Sue Hough, Mark Burrier

4.
Client	Frederick Festival of the Arts
Designers	Sue Hough, Mark Burrier

5.
Client	Top 2 Bottom Professional Cleaning
Designers	Sue Hough, Jack Sanger

6.
Client	Blue Ridge Community and Technical College
Designer	Sue Hough

7.
Client	Adams Warehouse No. 2
Designers	Sue Hough, Mark Burrier

(opposite)
Design Firm **Studio International**
Client	Hrvatsko dizajnersko drustvol/Croatian Designers Society
Designer	Boris Ljubicic

Hrvatsko dizajnersko društvo
Croatian Designers Society
Prilaz Gjure Deželića 20
10000 Zagreb
Croatia

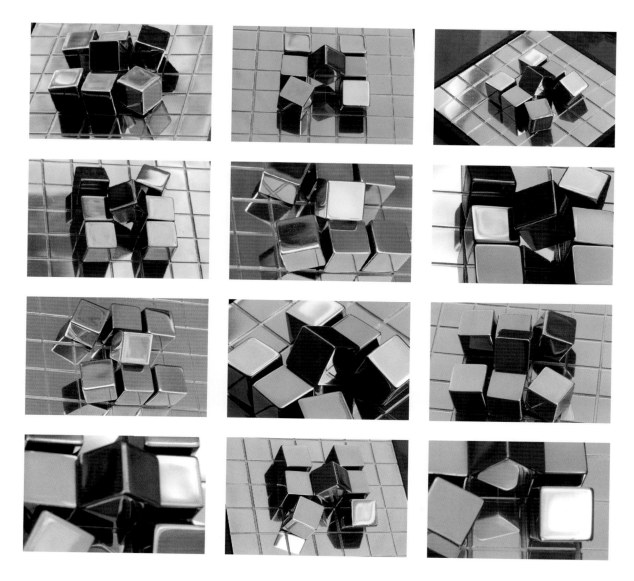

1.

2.

3.

4.

5.

6.

7.

8.

9.

10.

11.

12.

LEE
MUNRO
...the other car dealer

13.

14.

"BABBLING & BEYOND"

15.

1 - 4
Design Firm **Octavo Designs**
5 - 15
Design Firm **The Graffic Link
Design Studio Inc.**

1.
Client Strategic Partnerships International
Designers Sue Hough, Mark Burrier
2.
Client Richard Crouse & Associates, Inc.
Designers Sue Hough, Mark Burrier
3.
Client Briddell Builders
Designer Sue Hough
4.
Client Martinsburg-Berkeley
 County Libraries
Designers Sue Hough, Mark Burrier
5.
Client Bosco Farms
Designer Shane O'Brien
6.
Client Chris Friel
Designer Tim Pronk

7.
Client Niche Architectural
Designer Katarina Saric
8.
Client Brantford Golf and Country Club
Designer Shane O'Brien
9.
Client Janston Financial Group
Designer Katarina Saric
10.
Client Hazelton Place
Designer Katarina Saric
11.
Client Western Spring and Wire
Designer Katarina Saric
12.
Client Surf Rider
Designers Shane O'Brien, Katarina Saric
13, 14.
Client Lee Munro Chevrolet
Designer Shane O'Brien
15.
Client Talking Tots
Designer Shane O'Brien

1.

2.

L&S
LETTERS & SCIENCES

3.

NEXUS
communications, inc.

4.

5.

Fluent
Reading
Trainer

6.

7.

1
 Design Firm **The Graffic Link**
 Design Studio Inc.
2 - 4
 Design Firm **Robert Rumbaugh**
 Communications Design
5 - 7
 Design Firm **Boelts/Stratford Associates**
1.
 Client Floral Express
 Designer Katarina Saric
2.
 Client Robert Rumbaugh
 Communications Design
 Designer Robert Rumbaugh
3.
 Client Letters & Sciences
 Designer Robert Rumbaugh

4.
 Client Nexus Communications, Inc.
 Designer Robert Rumbaugh
5.
 Client Diamond Ventures
 Designers Kerry Stratford, Josh Campbell
6, 7.
 Client Mindplay
 Designers Kerry Stratford, Jackson Boelts,
 Rob Nicoletti
(opposite)
 Design Firm **StudioMoon / San Francisco**
 Client Nilou Nadershahi, D.D.S.,
 AnselmoSmile Dental
 Designers Tracy Moon, Monica Toan

1.

2.

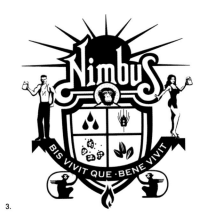

3.

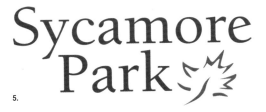

4.

Sycamore
Park

5.

6.

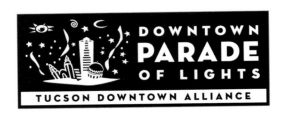

7.

1 - 7
Design Firm **Boelts/Stratford Associates**
1.
Client Fox Theatre, Tucson
Designer Kerry Stratford
2, 3.
Client Nimbus Brewing Company
Designer Jackson Boelts
4.
Client Diamond Ventures
Designers Kerry Stratford, Jackson Boelts
5.
Client Diamond Ventures
Designer Kerry Stratford

6.
Client Tucson Downtown Alliance
Designers Kerry Stratford, Jackson Boelts
7.
Client Tucson Museum of Art
Designer Kerry Stratford
(opposite)
Design Firm **Studio International**
Client Grad Kutina/Kutina City
Designer Boris Ljubicic

750 GODINA GRADA KUTINE

225

1.

2.

3.

4.

TEEBO

5.

6.

WINGMAN
Always has you covered

7.

orbital

8.

9.

10.

11.

Trame

12.

TOKYO
Train Equipment Suppliers

13.

THIRDEYE®
MOTION PICTURE STUDIO

14.

15.
Automotive Design Studio

1
 Design Firm **Boelts/Stratford Associates**
2 - 11
 Design Firm **Fpm media**
12 - 15
 Design Firm **Mamordesign**

1.
 Client Diamond Ventures
 Designer Kerry Stratford, Jackson Boelts
2.
 Client Med24
 Designer Fabians Marchinko
3.
 Client New Course Financial
 Designer Fabians Marchinko
4.
 Client First Home Buyers
 Designer Fabians Marchinko
5.
 Client Teebo Software
 Designer Fabians Marchinko
6.
 Client Shetland Coffee Company
 Designer Fabians Marchinko

7.
 Client Wingman Clothing
 Designer Fabians Marchinko
8.
 Client Orbital Surveys
 Designer Fabians Marchinko
9.
 Client Cash Yes!
 Designer Fabians Marchinko
10.
 Client Private Sale
 Designer Fabians Marchinko
11.
 Client Fusion One Media
 Designer Fabians Marchinko
12.
 Client Trame Print Center Inc.
 Designer Hojjat Babaei
13.
 Client Tokyo Train Equipment Inc.
 Designer Hojjat Babaei
14.
 Client Thirdeye Motion Picture Inc.
 Designer Hojjat Babaei
15.
 Client Shen Design Studio
 Designer Hojjat Babaei

1.

2.

3.

4.

5.

6.

7.

1 - 7
Design Firm **Mamordesign**
1.
Client PeranoTerexo
Designer Hojjat Babaei
2.
Client Kateb Publication Inc.
Designer Hojjat Babaei
3.
Client Clavin House Services Inc.
Designer Hojjat Babaei
4.
Client Chayya Beach Entertainment
Designer Hojjat Babaei
5.
Client Watery Carwash
Designer Hojjat Babaei

6.
Client Viva Design Studio
Designer Hojjat Babaei
7.
Client Veresk Group Inc.
Designer Hojjat Babaei
(opposite)
Design Firm **Studio International**
Client Hrvatski dokumentacijski
 centarl/Croatian
 Documentation Centre
Designer Boris Ljubicic

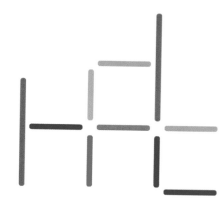

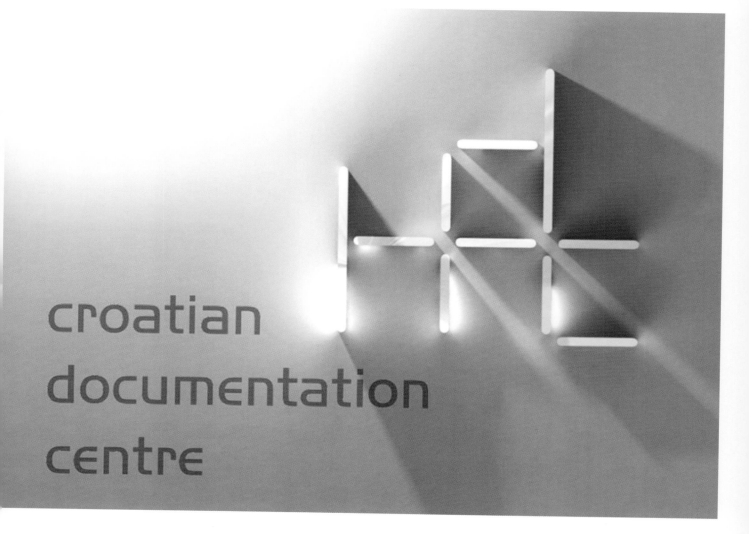

croatian
documentation
centre

1.

2.

3.

4.

5.

6.

7.

1 - 7
Design Firm **Mamordesign**
1.
 Client Topax Environmental
 Consultants Inc.
 Designer Hojjat Babaei
2.
 Client Thomas Travel Agency Inc.
 Designer Hojjat Babaei
3.
 Client Osvah Pharma Co.
 Designer Hojjat Babaei
4.
 Client Techlogica Industrial Group
 Designer Hojjat Babaei
5.
 Client Solix Packaging Co.
 Designer Hojjat Babaei

6.
 Client Shilamayesh Environmental
 Consultants
 Designer Hojjat Babaei
7.
 Client Solar Drink Co.
 Designer Hojjat Babaei
(**opposite**)
 Design Firm **Okan Usta**
 Client Unal Ciftligi Farm Cheese
 Manufacturer
 Designers Okan Usta

1.

Ezetimibe

2.

GLUTAZONE®

PIOGLYTAZON

3.

LISINOPRIL

4.

MIGRESTOP®

sumatriptan succinate

5.

CITALOPRAM

6.

Clopidogrel

7.

Piroxicam

8.

9.

10.

11.

12.

13.

14.

15.

1 - 15
Design Firm **Mamordesign**
1.
Client Child Channel TV
Designer Hojjat Babaei
2 - 9.
Client Osvah Pharma Co.
Designer Hojjat Babaei
10.
Client GAB Mushroom Co.
Designer Hojjat Babaei
11, 12.
Client Hera Infertility Care Center
Designer Hojjat Babaei
13.
Client Ice Dream Inc.
Designer Hojjat Babaei

14.
Client Mamordesign Studio
Designer Hojjat Babaei
15.
Client Moone Inc.
Designer Hojjat Babaei

1.

2.

3.

4.

5.

6.

7.

1 - 7
Design Firm **Mamordesign**
1.
Client Tehran University
Designer Hojjat Babaei
2.
Client Osvah Pharma Co.
Designer Hojjat Babaei
3.
Client ButterFly Travel Agency Inc.
Designer Hojjat Babaei
4.
Client Bumbling Honey Co.
Designer Hojjat Babaei
5.
Client Bluewater Drink Co.
Designer Hojjat Babaei

6.
Client Agrofooda Fair
Designer Hojjat Babaei
7.
Client Aalinoosh Beverage Co.
Designer Hojjat Babaei
(opposite)
Design Firm **Misenheimer Creative, Inc.**
Client City of Alpharetta, Georgia
Designer Mark Misenheimer

1.

2.

3.

4.

5.

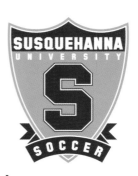

6.

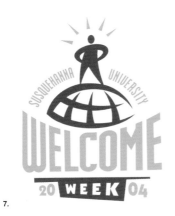

7.

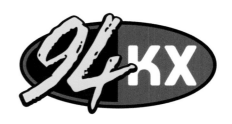

8.

9.

10.

11.

12.

13.

14.

15.

1, 2
 Design Firm **Mamordesign**
3 - 11
 Design Firm **MFDI**
12 - 15
 Design Firm **Icon Graphics Inc.**
1.
 Client Humana Medical Center
 Designer Hojjat Babaei
2.
 Client Cool Paint
 Designer Hojjat Babaei
3.
 Client Access Mortgage Funding
 Designer Mark Fertig
4.
 Client Results Fitness
 Designer Mark Fertig
5.
 Client Blue Ribbon Blossoms
 Designer Mark Fertig

6, 7.
 Client Susquehanna University
 Designer Mark Fertig
8 - 11.
 Client Sunbury Broadcasting Corporation
 Designer Mark Fertig
12.
 Client Monroe County High School
 Club Hockey League
 Designers Icon Graphics Inc.
13.
 Client Once Again Nut Butter Inc.
 Designers Icon Graphics Inc.
14.
 Client DDC Marketing Group
 Designers Icon Graphics Inc.
15.
 Client Global 20/20
 Designers Icon Graphics Inc.

1.

GENESEE VALLEY

PLEIN AIR PAINTERS

2.

3.

4.

ClearRelief™

5.

ARTISAN™
COLLECTION

6.

7.

1 - 7
Design Firm **Icon Graphics Inc.**
1.
 Client Lapp Insulators LLC
 Designers Icon Graphics, Inc.
2.
 Client Genesee Valley Plein
 Air Painters, Inc.
 Designers Icon Graphics, Inc.
3, 4.
 Client The Lodge at Woodcliff
 Designers Icon Graphics, Inc.
5.
 Client Vital Needs International, L.P.
 Designers Icon Graphics, Inc.

6.
 Client Brush Strokes Fine Art Inc.
 Designers Icon Graphics, Inc.
7.
 Client Bridgeway Leadership, Inc.
 Designers Icon Graphics, Inc.
(opposite)
 Design Firm **Sayles Graphic Design**
 Client Knoxville Raceway
 Designer John Sayles

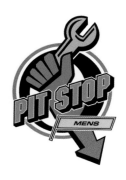

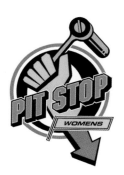

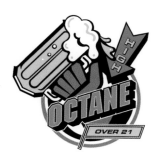

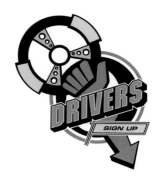

1.

2.

3.

4.

5.

6.

7.

1
Design Firm **Subplot Design Inc.**
2
Design Firm **FDT Design, NY**
3
Design Firm **Graphis, Istanbul**
4 - 6
Design Firm **Okan Usta**
7
Design Firm **Studio International**

1.
Client Tennis BC
Designers Matthew Clark, Roy White
2.
Client Toy Industry Association, Inc.
Designer Okan Usta
3.
Client Motus Sports and Wellness Center
Designer Okan Usta
4.
Client Eddy's Clothing Studio
Designer Okan Usta

5.
Client Dizayn Interior Design Studio
Designer Okan Usta
6.
Client Bagg Interior Design Studio
Designer Okan Usta
7.
Client Hrvatski Autoklub/Croatian Autoclub
Designer Boris Ljubicic
(opposite)
Design Firm **Studio International**
Client Croata, Zagreb, Croatia
Designer Boris Ljubicic

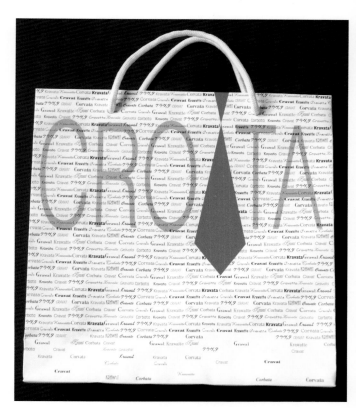

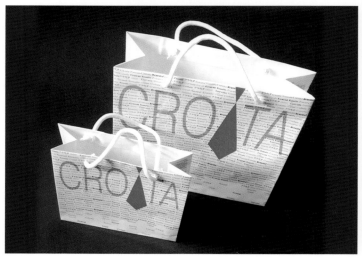

1.

2.

Palamut Group

3.

4.

5.

THE MERIDIAN

6.

THE OUTLETS AT
VERO BEACH℠
FASHION, STYLE & MORE

7.

UNIVERSITY
MALL

8.

CELEBRATING 100 YEARS OF
THE SOUTHEAST MISSOURIAN

9.

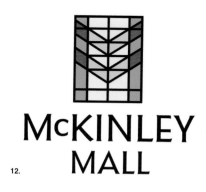

CENTENNIAL
CELEBRATING 100 YEARS OF
THE SOUTHEAST MISSOURIAN

10.

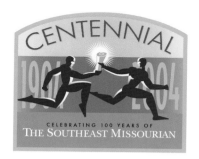

CENTENNIAL
CELEBRATING 100 YEARS OF
THE SOUTHEAST MISSOURIAN

11.

McKINLEY
MALL

12.

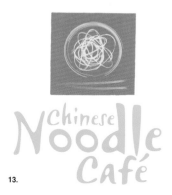

Chinese
Noodle
Café

13.

COVENTRY
MALL

14.

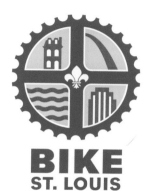

BIKE
ST. LOUIS

15.

1 - 4
Design Firm **Okan Usta**
5 - 15
Design Firm **Kiku Obata & Company**
1.
Client Social Organizations Society
Designers Okan Usta
2.
Client TURKCELL
Designers Okan Usta
3.
Client Palamut Group
Designers Okan Usta
4.
Client Sinefekt Post Production Company
Designers Okan Usta
5.
Client Miss Saigon
Designers Rich Nelson
6.
Client The Meridian
Designers Rich Nelson

7.
Client The Outlets at Vero Beach/Stoltz
Designer Amy Knopf
8.
Client University Mall/Stoltz
Designer Joe Floresca
9 - 11.
Client Southeast Missourian Centennial
Designer Rich Nelson
12.
Client McKinley Mall/Stolz
Designer Paul Scherfling
13.
Client Chinese Noodle Cafe
Designer Rich Nelson
14.
Client Coventry Mall/Stoltz
Designer Amy Knopf
15.
Client Bike St. Louis
Designer Troy Guzman

1.

2.

3.

4.

5.

6.

7.

1 - 3
Design Firm **Anchor Point Design**
4 - 7
Design Firm **Colin Magnuson Creative**

1.
Client Real Estate Strategies
Designer David Ordaz

2.
Client OP Electric
Designer David Ordaz

3.
Client Ilant Group Design
Designer David Ordaz

4.
Client WaterSide Lane
Designer Colin Magnuson

5.
Client Tacoma Monument
Designer Colin Magnuson

6, 7.
Client Boston Harbor
Designer Colin Magnuson

(opposite)
Design Firm **Studio International**
Client Hrvatski rukometni savez/
 Croatian Handball Association
Designer Boris Ljubicic

1.

2.

3.

4.

5.

6.

7.

1 - 7
Design Firm **Colin Magnuson Creative**
1 - 3.
Client WestBlock Systems
Designer Colin Magnuson
4.
Client Mandalay Townhomes
Designer Colin Magnuson
5.
Client Lordin Professional Services
Designer Colin Magnuson
6.
Client Umani
Designer Colin Magnuson
7.
Client Flags a Flying
Designer Colin Magnuson

(opposite)
Design Firm **Studio International**
Client Simecki Shoe Factory
Designer Boris Ljubicic

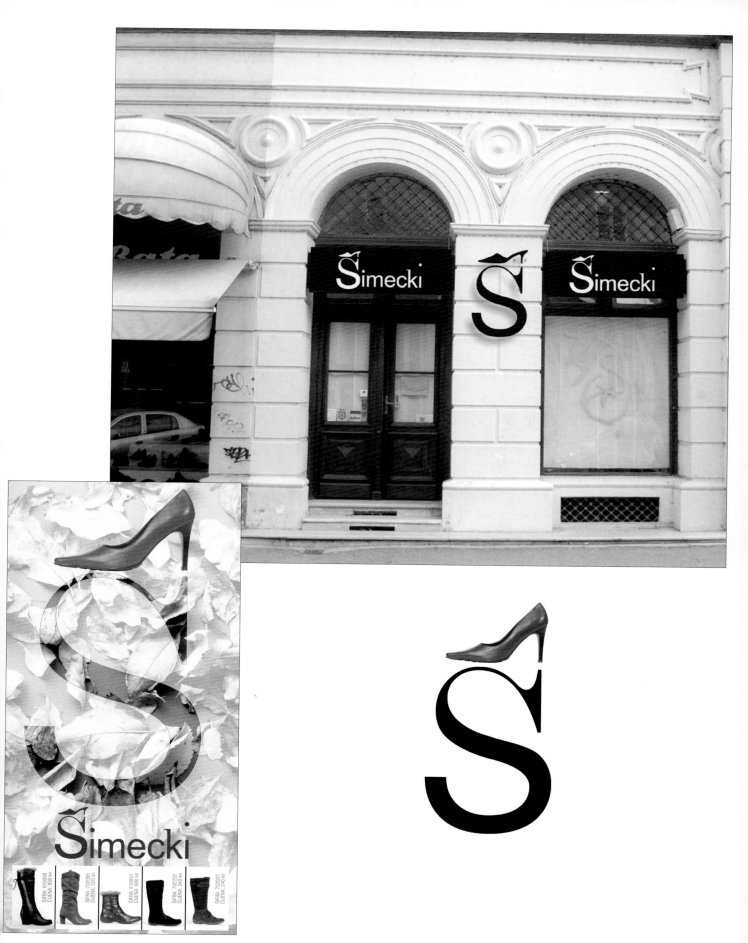

1.

2.

3.

4.

5.

6.

7.

8.

9.

10.

11.

12.

13.

14.

15.

1 - 14
Design Firm **Colin Magnuson Creative**

15
Design Firm **Beirut Graphics**

1.
Client 38th St Service Center
Designer Colin Magnuson

2.
Client Alicia Meadows Townhomes
Designer Colin Magnuson

3.
Client Atlas Services
Designer Colin Magnuson

4.
Client Battson Coaching
Designer Colin Magnuson

5, 6.
Client Boston Harbor Land Company
Designer Colin Magnuson

7.
Client Chatelain Property Management
Designer Colin Magnuson

8.
Client Courtney Ridge Townhomes
Designer Colin Magnuson

9.
Client Crest Builders
Designer Colin Magnuson

10.
Client Deer Valley
Designer Colin Magnuson

11.
Client Friday's Cookies
Designer Colin Magnuson

12.
Client Fueston Group
Designer Colin Magnuson

13.
Client Parkinson Painting
Designer Colin Magnuson

14.
Client Rueppell Home Design
Designer Colin Magnuson

15.
Client Abbar and Zeiny Group,
Saudi Arabia
Designer Kameel Hawa

1.

2.

3.

4.

5.

6.

7.

1 - 7
Design Firm **Beirut Graphics**
1.
 Client Arab
 Designer Kameel Hawa
2.
 Client Thought Foundation, Lebanon
 Designer Yara Khoury
3.
 Client Al Abniah Contracting Co.,
 Saudi Arabia
 Designer Greta Khoury
4.
 Client Baashen Co., Saudi Arabia
 Designers Kameel Hawa, Greta Khoury
5, 6.
 Client Douaihy Sweets, Lebanon
 Designer Yara Khoury, Maya Rizkallah

7.
 Client Hawa Audio, Syria
 Designer Kameel Hawa
(opposite)
 Design Firm **Misenheimer Creative, Inc.**
 Client Johns-Creek-Playhouse/
 Geoffrey Berlin
 Designer Mark Misenheimer

1.

2.

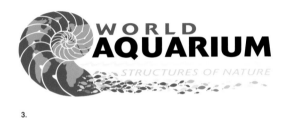

3.

4.

5.

6.

7.

1, 2
Design Firm **Beirut Graphics**
3 - 7
Design Firm **Bright Rain Creative**
1.
Client Beirut Graphics, Lebanon
Designer Kameel Hawa
2.
Client Shobokshi Development Co.
Designer Yara Khoury
3.
Client World Aquarium
Designers Matt Marino, Kevin Hough
4.
Client Vigilex LLC
Designers David Hough, Matt Marino

5.
Client St. Louis YPO
Designer Kevin Hough
6.
Client Net Benefit
Designer Kevin Hough
7.
Client Elizabeth Burns Design
Designers Kevin Hough, David Hough,
 Elizabeth Burns
(opposite)
Design Firm **Flowdesign, Inc.**
Client Kar's Nut Products Company
Designers Dan Matauch,
 Dennis Nalezyty

1.

2.

3.

4.

5.

6.

7.

8.

9.

10.

11.

Shumock + Anderson LLC
CERTIFIED PUBLIC ACCOUNTANTS

12.

MSH MITSUI STEEL HOLDINGS, INC.

13.

UNIQUE
WINDOW TREATMENTS

14.

SWORD
DIAGNOSTICS

15.

1 - 12
Design Firm **Pixallure Design**
13 - 15
Design Firm **Graphic Advance, Inc.**

1.
 Client Anchor Security
 Designers Steven Lutz, Terry Edeker
2.
 Client Century21
 Designers Steven Lutz, Terry Edeker
3.
 Client Circle G Farms
 Designer Terry Edeker
4.
 Client CM Group
 Designers Steven Lutz, Terry Edeker
5.
 Client Gulf Coast Kitchen & Bath
 Designers Terry Edeker, Steven Lutz
6.
 Client Ladas Development
 Designers Steven Lutz, Terry Edeker
7.
 Client McConnell Automotive
 Designers Steven Lutz, Terry Edeker

8.
 Client ODO
 Designers Steven Lutz, Terry Edeker
9.
 Client Offshore Inland
 Designers Steven Lutz, Terry Edeker
10.
 Client Roussos Restaurant
 Designers Steven Lutz, Terry Edeker
11.
 Client Safe Archives
 Designers Steven Lutz, Nancy Hughes
12.
 Client Shumock Anderson
 Designer Terry Edeker
13.
 Client Mitsui Steel Holdings, Inc.
 Designer Aviad Stark
14.
 Client Unique Window Treatments
 Designer Aviad Stark
15.
 Client Sword Diagnostics
 Designer Aviad Stark

1.

2.

3.

4.

5.

6.

7.

1 - 7
Design Firm **Graphic Advance, Inc.**
1.
Client GNR Equities
Designer Aviad Stark
2.
Client Giant Steps
Designer Aviad Stark
3.
Client Marasim
Designer Aviad Stark
4.
Client Mr Locks Security Systems
Designer Aviad Stark
5.
Client Nurel Events
Designer Aviad Stark

6.
Client Picowave Technologies
Designer Aviad Stark
7.
Client Saash
Designer Aviad Stark
(opposite)
Design Firm **Flowdesign, Inc.**
Client Thanasi Foods
Designers Dan Matauch,
 Dennis Nalezyty

1.

2.

3.

4.

5.

6.

7.

1 - 7
Design Firm **Schafer Design**
1.
Client TheCriticalEar.com Audio Website
Designer Todd Schafer
2.
Client Siers Construction, San Jose CA
Designer Todd Schafer
3.
Client Schafer Design
Designer Todd Schafer
4.
Client Santa Cruz Landscape &
 Maintenance
Designer Todd Schafer
5.
Client Michael McDonald Realtor
Designer Todd Schafer

6.
Client Independent Enterprises, Inc.
Designer Todd Schafer
7.
Client A Brit of Trivia
Designer Todd Schafer
(opposite)
Design Firm **Flowdesign, Inc.**
Client Punati Chemical
Designers Dan Matauch,
 Dennis Nalezyty

1.

2.

3.

4.

5.

6.

7.

8.

9.

10.

11.

12.

13.

14.

15.

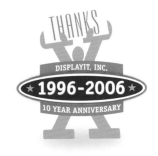

1.

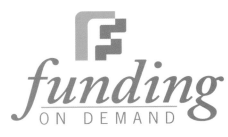

2.

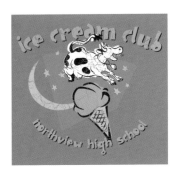

3.

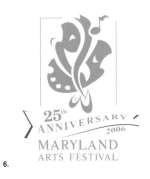

TELECOM
SAVANT

4.

Central
BAPTIST CHURCH

5.

25th
ANNIVERSARY
2006
MARYLAND
ARTS FESTIVAL

6.

String Day
2006

OCTOBER 27

TOWSON UNIVERSITY

7.

1 - 5
Design Firm **Misenheimer Creative, Inc.**
6, 7
Design Firm **The Design Center**
1.
Client Display It-Josh Axelberd
Designer Mark Misenheimer
2.
Client Funding on Demand-Josh Axelberd
Designer Mark Misenheimer
3.
Client Northview High School
 Ice Cream Club
Designer Mark Misenheimer
4.
Client Stephen Gilkenson
Designer Mark Misenheimer
5.
Client Central Baptist
Designer Mark Misenheimer

6.
Client Maryland Arts Festival
Designer The Design Center
7.
Client Towson University
Designer The Design Center
(opposite)
Design Firm **Truefaces Creation Sdn Bhd**
Client Sime UEP Properties Berhad
Designers Truefaces Creative Team

1.

2.

3.

SILOS GRILL

HOME MADE HOSPITALITY

4.

FRANCIS HOWARD
GALLERIES

5.

Dr. John Trent's
STRONGFAMILIES®
Changing the World One Family at a Time

6.

JOHNS CREEK
CHAMBER of COMMERCE

7.

1 - 7
Design Firm **Misenheimer Creative, Inc.**
1.
 Client Vanessa Lowry
 Designer Mark Misenheimer
2.
 Client Network TwentyOne
 Designer Mark Misenheimer
3.
 Client Misenheimer Creative, Inc.
 Designer Mark Misenheimer
4.
 Client Silos Grill
 Designer Mark Misenheimer
5.
 Client Walt Geer
 Designer Mark Misenheimer
6.
 Client Dr. John Trent/Strong Families
 Designer Mark Misenheimer

7.
 Client Johns-Creek-Chamber
 of Commerce
 Designer Mark Misenheimer
(opposite)
 Design Firm **StudioMoon/San Francisco**
 Client Stephanie Miller, Aishe Berger,
 SF Puppy Prep
 Designer Tracy Moon

1.

2.

3.

4.

5.

6.

7.

8.

272

9.

10.

11.

12.

13.

IMAGING
Dynamics

14.

15.

1 - 15
Design Firm **Misenheimer Creative, Inc.**
1.
Client Royal Oaks Elementary School PTA
Designer Mark Misenheimer
2, 3.
Client Phenix Direct
Designer Mark Misenheimer
4 - 7.
Client Core Foundations—Release
 Time Learning
Designer Mark Misenheimer
8.
Client EcoBoost
Designer Mark Misenheimer
9.
Client Tiffany Alley—Certified
 Court Reporters / Global Connex
Designer Mark Misenheimer

10.
Client Zeal USA
Designer Mark Misenheimer
11.
Client The Freight Accounting & Payment
 Management Association
Designer Mark Misenheimer
12, 13.
Client Perimeter Church
Designer Mark Misenheimer
14.
Client Imaging Dynamics
Designer Mark Misenheimer
15.
Client Procyse / Hotwire Marketing
Designer Mark Misenheimer

273

MASSAGE & BODYWORK OF SANIBEL ISLAND

1.

2.

TIFFANY A⊕A ALLEY
certified reporters

3.

NEO*Therm*A
The Waste Transformation Company

4.

Golsen FAMILY
Dentistry

5.

everyday steward
a division of **RonaldBlue**&Co.

6.

7.

1
 Design Firm **Sanibel Film School**
2 - 7
 Design Firm **Misenheimer Creative, Inc.**
1.
 Client Massage & Bodywork
 of Sanibel Island
 Designer Matilda Carter
2.
 Client Network TwentyOne
 Designer Mark Misenheimer
3.
 Client tiffany alley
 Designer Mark Misenheimer
4.
 Designer Mark Misenheimer

5.
 Client Golsen Family Dentistry
 Designer Mark Misenheimer
6.
 Client Ron Blue & Company
 Designer Mark Misenheimer
7.
 Client ACE Ideas Consulting
 Designer Mark Misenheimer
(opposite)
 Design Firm **Studio International**
 Client Varteks
 Designer Boris Ljubicic

1.

2.

3.

4.

5.

6.

7.

1 - 7
Design Firm **Misenheimer Creative, Inc.**
1.
Designer Mark Misenheimer
2.
Client Videoscopic Institute of Atlanta
Designer Mark Misenheimer
3.
Client Misenheimer Creative, Inc.
Designer Mark Misenheimer
4 - 7.
Client A & I Solutions
Designer Mark Misenheimer

(opposite)
Design Firm **Studio International**
Client SMS Industry of Healthy Food
Designer Boris Ljubicic

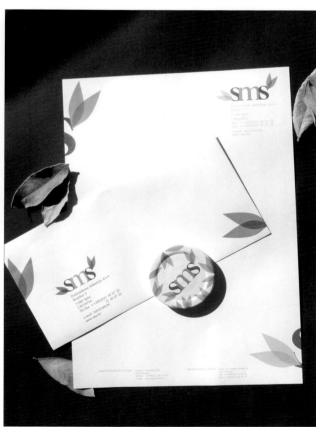

1.

2.

3.

4.

5.

6.

7.

8.

9.

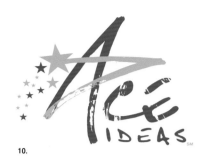

10.

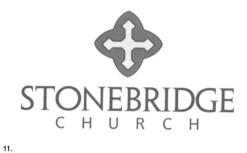

11.

The PLAZA AT SUWANEE STATION

12.

Atlanta Montessori Academy

13.

THE TalMar COMPANIES
REAL ESTATE entitlement | acquisitions | development

14.

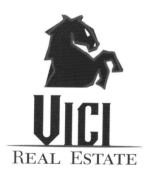
VICI REAL ESTATE

15.

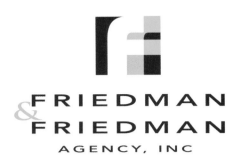

FRIEDMAN
&
FRIEDMAN
AGENCY, INC

1.

LANE

2.

THE
KLARER
LAW
FIRM
P.C.

3.

4.

THE MAINE MAID INN
est. 1789

5.

THALER GERTLER
LLP

6.

WESTBURY

VILLAGE

7.

1 - 7
Design Firm **Guarino Graphics Ltd**
1.
 Client Friedman & Friedman Insurance
 Designer Jan Guarino
2.
 Client Atlantic Holdings
 Designer Jan Guarino
3.
 Client The Klarer Law Firm
 Designer Jan Guarino
4.
 Client D&F Development
 Designer Jan Guarino
5.
 Client Lessings
 Designer Jan Guarino
6.
 Client Thaler Gertler Law Firm
 Designer Jan Guarino

7.
 Client Westbury Village
 Designer Jan Guarino
(opposite)
 Design Firm **Flowdesign, Inc.**
 Client XanGo
 Designers Dan Matauch,
 Dennis Nalezyty

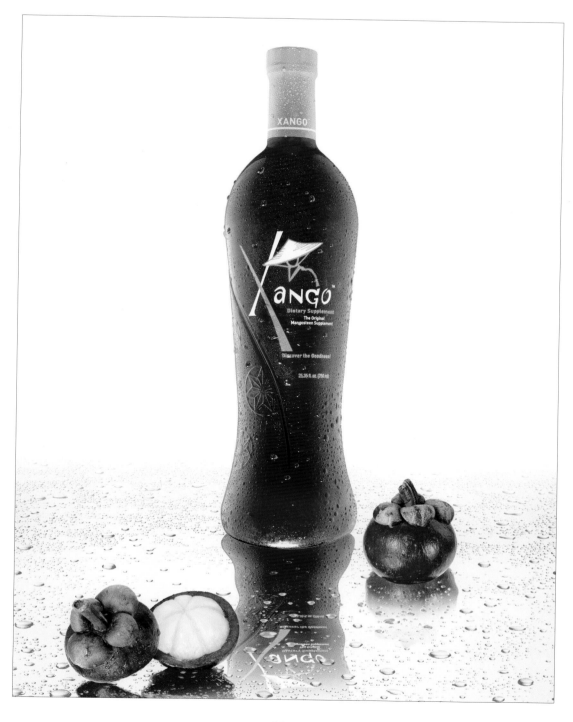

1.

FusionFest

2.

3.

FIESTA

4.

5.

6.

SLOVENSKO PRAVO
IN GOSPODARSTVO
OB VSTOPU SLOVENIJE V
EVROPSKO UNIJO

7.

1 - 5
Design Firm **Karen Skunta & Company**
6, 7
Design Firm **KROG, Ljubljana**

1, 2.
Client The Cleveland Play House
Designers Jamie L. Finkelhor,
 Karen A. Skunta

3.
Client TravelCenters of America
Designers Jamie L. Finkelhor, Jenny Pan,
 Karen A. Skunta

4.
Client Fiesta Yarns
Designers Jenny Pan, Karen A. Skunta

5.
Client BeadCrafters
Designers Christopher Suster,
 Karen A. Skunta

6.
Client Edi Berk, Ljubljana
Designer Edi Berk

7.
Client Pravna fakulteta, Ljubljana
Designer Edi Berk
(opposite)
Design Firm **Herip Design Associates**
Client Heritage Farms
Designers Walter M. Herip, John R. Menter
 Jen Hollo Crabtree

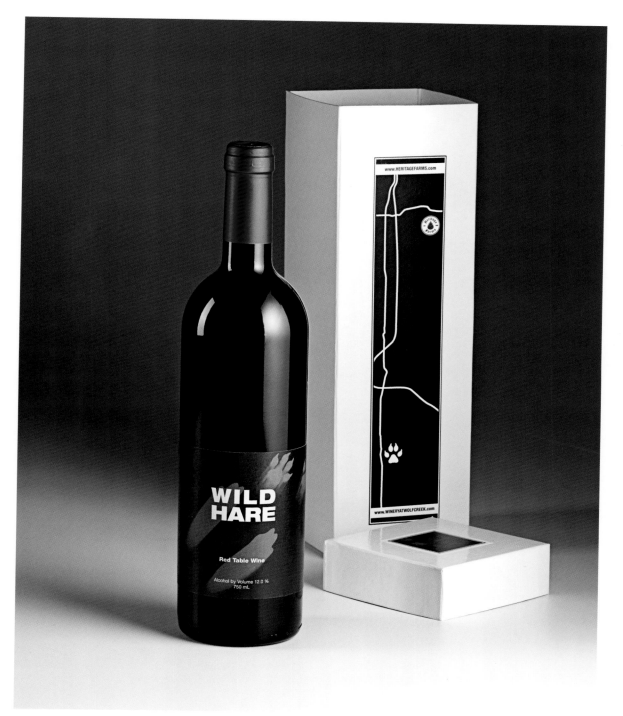

1.

2.

3.

4.

5.

6.

7.

8.

9.

10.

11.

12.

Evro-za vse nas

13.

slovenija
moja vinska dežela

14.

abama

15.

1 - 15			11.		
Design Firm	**KROG, Ljubljana**		Client	Andrej Kos, Rošpoh pri Kamnici	
1 - 4.			Designer	Edi Berk	
Client	Hotel Mons, Ljubljana		12, 13.		
Designer	Edi Berk		Client	Urad za informiranje Republike Slovenije	
5.					
Client	Vinovin, Ljubljana		Designer	Edi Berk	
Designer	Edi Berk		14.		
6.			Client	Vinska družba Slovenije	
Client	Gomline, Ljubljana		Designer	Edi Berk	
Designer	Edi Berk		15.		
7.			Client	Abama, Ljubljana	
Client	Valter Mlečnik, Bukovica		Designer	Edi Berk	
Designer	Edi Berk				
8.					
Client	Intel servis, Novo mesto				
Designer	Edi Berk				
9.					
Client	Hernaus, Velenje				
Designer	Edi Berk				
10.					
Client	KVM Grafika				
Designer	Edi Berk				

New Mount Moriah
MISSIONARY BAPTIST CHURCH

1.

Green River Technology

2.

Temporary Tattoos

3.

Westgate

4.

mCoyGroup

5.

The Arborlands

6.

PENINSULA FIBER CAFE

7.

1 - 3
Design Firm **SKA Studios**
4 - 7
Design Firm **Herip Design Associates, Inc.**
1.
Client — New Mount Moriah Missionary Baptist Church
Designer — Sheri K. Audette
2.
Client — New Green River Technology
Designer — Sheri K. Audette
3.
Client — New Zoo Dog's Temporary Tattoos
Designer — Sheri K. Audette
4.
Client — The Richard E, Jacobs Group
Designers — Walter M. Herip, John R. Menter
5.
Client — mCoyGroup
Designers — Walter M. Herip, John R. Menter Jen Hollo Crabtree

6.
Client — The Richard E, Jacobs Group
Designers — Walter M. Herip, John R. Menter
7.
Client — Peninsula Fiber Cafe
Designer — Walter M. Herip
(opposite)
Design Firm **KROG, Ljubljana**
Client — Zlati grič, Slovenske Konjice
Designer — Edi Berk

1.

2.

3.

4.

5.

6.

7.

1 - 7
 Design Firm **Herip Design Associates, Inc.**
1, 2.
 Client Cuyahoga Valley Countryside
 Conservancy
 Designers Walter M. Herip,
 Jen Hollo Crabtree
3 - 5.
 Client Forest City Military Communities
 Designers Walter M. Herip, John R. Menter,
 Jen Hollo Crabtree
6.
 Client The Richard E, Jacobs Group
 Designers Walter M. Herip,
 Jen Hollo Crabtree
7.
 Client Forest City Washington
 Designers Walter M. Herip,
 Jen Hollo Crabtree

(opposite)
 Design Firm **KROG, Ljubljana**
 Client Tehcenter, Ptuj
 Designer Edi Berk

1.

2.

3.

4.

5.

6.

7.

8.

Handcrafted
BY KIDZ

9.

10.

THE
PRESIDENT'S OWN

11.

BRIX & COMPANY

12.

INSIGNIA™
A HANGER INNOVATION

13.

14.

15.

1.

2.

3.

4.

5.

6.

JEFFREY J. TIBBS, D.D.S., P.A.

Performing Dental Miracles

7.

1 - 6
Design Firm **Red Door Interactive**
7
Design Firm **Fifth Letter**

1.
Client Benetrac
Designers Roy Dequina,
 Jeannie Metz-Fratoni

2.
Client Idego Methodologies
Designers Jeannie Metz-Fratoni,
 Amanda Handriani

3.
Client Therapeutics Inc.
Designers Jeannie Metz-Fratoni, Brian Tsang,
 Brent Ross

4.
Client Amulaire Thermal Technology
Designers Jason Elsmore,
 Jeannie Metz-Fratoni

5.
Client Nanogen
Designer Jeannie Metz-Fratoni

6.
Client Red Door Interactive
Designer Jeannie Metz-Fratoni

7.
Client Dr. Jeffrey J. Tibbs
Designer Elliot Strunk

(opposite)
Design Firm **Herip Design Associates, Inc.**
Client Forest City Washington—The Yards
Designers Walter M. Herip,
 Jen Hollo Crabtree,
 John R. Menter

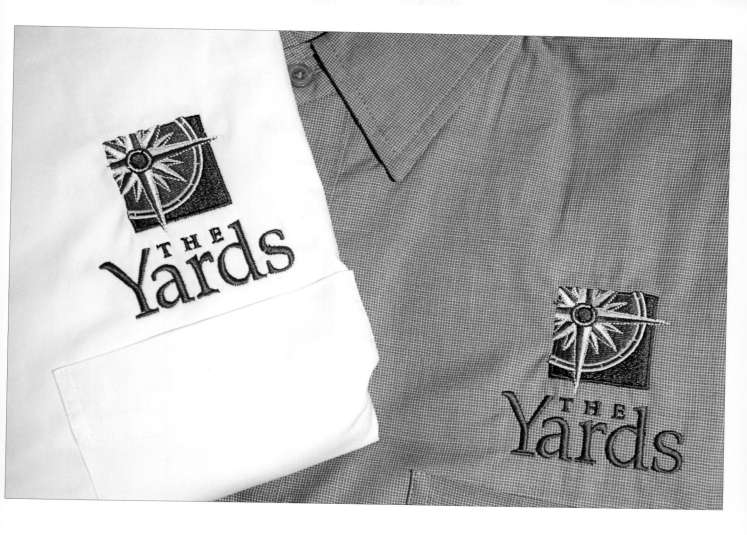

293

1.

2.

3.

4.

5.

6.

7.

1 - 7
Design Firm **Fifth Letter**
1, 2.
 Client Renaissance Theatre Company
 Designer Elliot Strunk
3.
 Client Bill Gruener
 Designer Elliot Strunk
4.
 Client Enviro-Air Solutions
 Designer Elliot Strunk
5 - 7.
 Client Ooga Booga, Inc.
 Designers Elliot Strunk, Jim Paillot

(opposite)
 Design Firm **Studio International**
 Client Hrvatska Radio Televizijal/
 Croatian Radio Television
 Designer Boris Ljubicic

1.

2.

3.

4.

5.

6.

7.

8.

9.

10.

ON THE FRINGE
salon

11.

12.

13.

14.

15.

1.

2.

3.

4.

5.

6.

7.

1 - 4
Design Firm **angryporcupine*design**
5 - 7
Design Firm **BrandSavvy, Inc.**
1.
Client Cheryl Dailey Makeup + Hair
Designer Cheryl Roder-Quill
2.
Client StreamWorks Consulting
Designer Cheryl Roder-Quill
3.
Client Cloud City Creative
Designer Cheryl Roder-Quill
4.
Client Trevor Davies
Designer Cheryl Roder-Quill
5.
Client Unified Western Grocers,
 Gourmet Specialties
Designer Karl Peters

6.
Client Tampa Bay Heart Institute
Designer Scott Surine
7.
Client Hanksville Hot Rods
Designer Karl Peters
(**opposite**)
Design Firm **Herip Design Associates, Inc.**
Client The Richard E. Jacobs Group
Designers Walter M. Herip,
 John R. Menter

1.

2.

3.

4.

5.

6.

7.

1 - 7
Design Firm **BrandSavvy, Inc.**

1.
Client Oregon Health & Science University
Designers Karl Peters, Marcus Fitzgibbons,
 Scott Surine

2.
Client Indian River Medical Center
Designer Karl Peters

3.
Client ALPS Mutual Finds
Designer Karl Peters

4.
Client Cancer Navigators
Designer Karl Peters

5.
Client Brian Olsen, Art in Action
Designer Karl Peters

6.
Client Triad Consulting Group Inc.
Designer Marcus Fitzgibbons

7.
Client Retirement Strategies & Investments
Designers Scott Mahlmeister, Karl Peters
(opposite)
Design Firm **Studio International**
Client Muzejski dokumentacijski centar/
 Museum Documentation Centre
Designer Boris Ljubicic

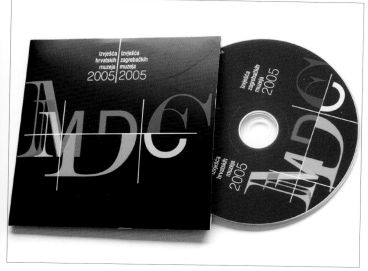

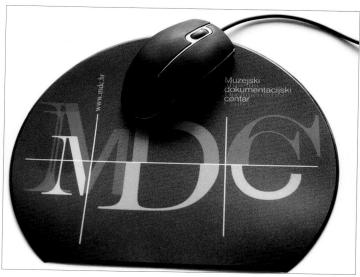

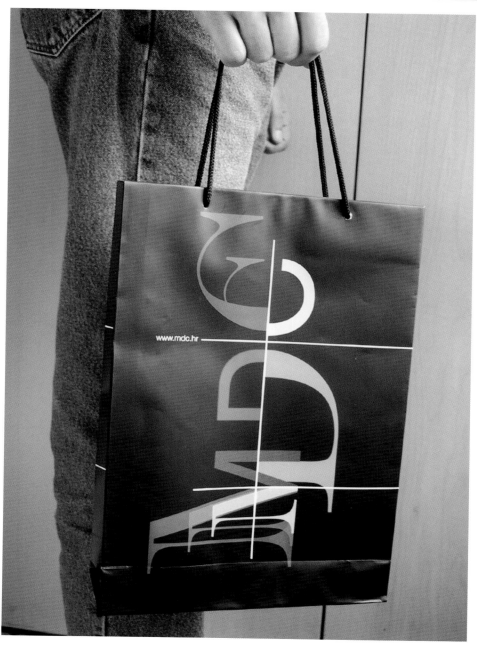

301

1.

2.

3.

4.

5.

6.

7.

8.

9.

10.

11.

12.

13.

14.

15.

1 - 4			9.		
Design Firm	**Look Design**			Client	Vantage Pointe
5 - 15				Designer	Alexander Atkins
Design Firm	**Alexander Atkins Design, Inc.**		10.		
1.				Client	Stanford University Hospital
	Client	Amoura		Designer	Alexander Atkins
	Designer	Pam Matsuda	11- 13.		
2.				Client	Stanford Graduate School
	Client	Footprint Retail Services			of Business
	Designer	Qui Tong		Designer	Alexander Atkins
3.			14.		
	Client	Lahlouh		Client	Spiral Communications
	Designer	Monika Kegel		Designer	Alexander Atkins
4.			15.		
	Client	U3		Client	Skinny Sippin
	Designers	Andrew Henderson, Look Design,		Designer	Alexander Atkins
		Betsy Todd			
5 - 7.					
	Client	Wind River Systems			
	Designer	Alexander Atkins			
8.					
	Client	YWCA			
	Designer	Alexander Atkins			

1.

2.

3.

4.

5.

6.

7.

1 - 7
Design Firm **Alexander Atkins Design, Inc.**
1.
Client Menlo College
Designer Alexander Atkins
2.
Client Pinewood School
Designer Alexander Atkins
3.
Client CourtWorks
Designer Alexander Atkins
4.
Client Rachel Copywriting
Designer Alexander Atkins
5, 6.
Client Stanford Graduate School
 of Business
Designer Alexander Atkins
7.
Client Second Harvest Food Bank
Designer Alexander Atkins

(opposite)
Design Firm **Studio International**
Client International Committee of
 Mediterranean Games
Designer Boris Ljubicic

1.

2.

3.

4.

5.

6.

7.

1 - 7
Design Firm **Alexander Atkins Design, Inc.**

1, 2.
Client Los Altos Hills
Designer Alexander Atkins

3.
Client Landscape Innovations
Designer Alexander Atkins

4.
Client Don and Geri Marek
Designer Alexander Atkins

5.
Client Mareks Restaurant
Designer Alexander Atkins

6.
Client Menlo College
Designer Alexander Atkins

7.
Client Nicole and Natalie Atkins
Designer Alexander Atkins

(opposite)
Design Firm **StudioMoon/San Francisco**
Client Jeff Weinstock,
 Big City Improv/San Francisco
Designers Tracy Moon, Jessie Bazata

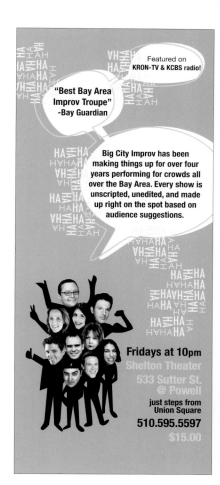

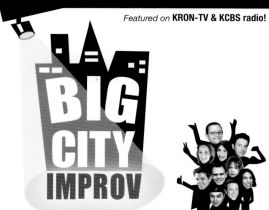

307

1.

2.

3.

4.

5.

6.

7.

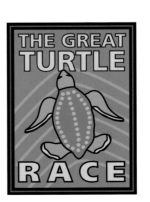

8.

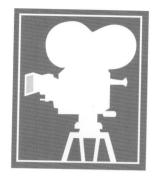

9.

10.

11.

12.

13.

SURGRX

14.

15.

1 - 15
Design Firm **Alexander Atkins Design, Inc.**

1, 2.
Client Los Altos Hills
Designer Alexander Atkins

3.
Client TheatreWorks
Designer Alexander Atkins

4.
Client Joy Letters, Inc.
Designer Alexander Atkins

5.
Client Jackson Library, Stanford University
Designer Alexander Atkins

6.
Client Heritage Residential Funding
Designer Alexander Atkins

7.
Client Stanford Graduate School
 of Business
Designer Alexander Atkins

8.
Client The Great Turtle Race
Designer Alexander Atkins

9.
Client Faulkner Films, Inc.
Designer Alexander Atkins

10.
Client Del Valle Communications
Designer Alexander Atkins

11.
Client TheatreWorks
Designer Alexander Atkins

12.
Client University of California, Berkeley
Designer Alexander Atkins

13.
Client Capri, Inc.
Designer Alexander Atkins

14.
Client Surgx
Designer Alexander Atkins

15.
Client Bullis Charter School
Designer Alexander Atkins

1.

2.

3.

THE BULLIS-
PURISSIMA
ELEMENTARY
SCHOOL
FOUNDATION

4.

PIRATES OF PENZANCE

5.

ENDOW THE FUTURE

6.

BELLARMINE
TRAVEL
ADVENTURES

7.

1 - 7
Design Firm **Alexander Atkins Design, Inc.**
1.
 Client Allison Atkins
 Designer Alexander Atkins
2 - 5.
 Client Bullis Charter School
 Designer Alexander Atkins
6, 7.
 Client Bellarmine College Preparatory
 Designer Alexander Atkins

(opposite)
 Design Firm **Studio International**
 Client Franck, Zagreb, Croatia
 Designer Boris Ljubicic

310

NEW JERSEY
COMMUNITY RESOURCE CENTER

9.

SENA KEAN
M A N O R

10.

Touching Lives
Lifting Spirits

11.

itTakes2™
WHERE CUPID WORKS

12.

13.

V·A·S·T·A·R·D·I·S
C A P I T A L S E R V I C E S

14.

15.

1.

2.

3.

4.

5.

6.

7.

1 - 7
Design Firm **Jacob Tyler Creative Group**
1.
Client Optimum Health Insurance
Designer Les Kollegian
2.
Client RMA Genetics
Designer Les Kollegian
3.
Client SAI Advantium
Designer Les Kollegian
4.
Client Total Logistic Control
Designer Les Kollegian
5.
Client University Thongs
Designer Les Kollegian
6.
Client Marinalife, Inc.
Designer Les Kollegian

7.
Client Memories By The Page
Designer Les Kollegian
(opposite)
Design Firm **Anchor Point Design**
Client La Bastide Bistro
Designer David Ordaz

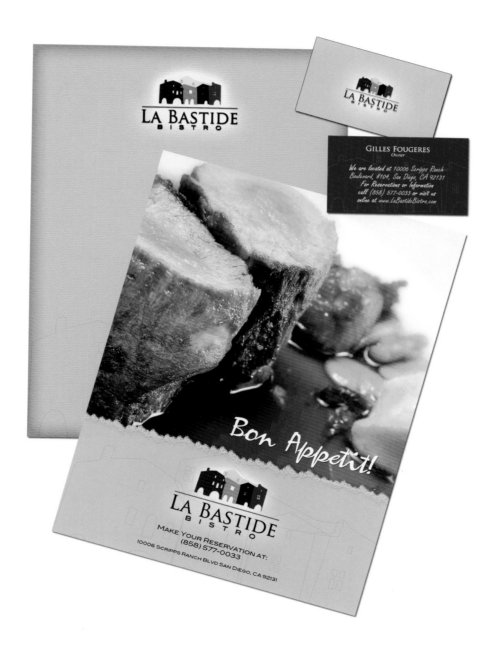

1.

2.

3.

4.

5.

6.

Luci
create digital memories to share

7.

1 - 7
Design Firm **Jacob Tyler Creative Group**
1.
Client Baltimore Inner Harbor
 Marine Center
Designer Les Kollegian
2.
Client D Cubed Equipment
Designer Les Kollegian
3.
Client Dalina Law Group
Designer Les Kollegian
4.
Client Disc Dealer, Inc.
Designer Les Kollegian
5.
Client Extreme Ecommerce, Inc.
Designers Les Kollegian, Richard Tross

6.
Client Iteam Technology Associates
Designer Les Kollegian
7.
Client Lucidiom, Inc.
Designer Les Kollegian
(opposite)
Design Firm **Koch Creative Group**
Client Youth Entrepreneurs of Kansas
Designers Dustin Commer, Kay Davis

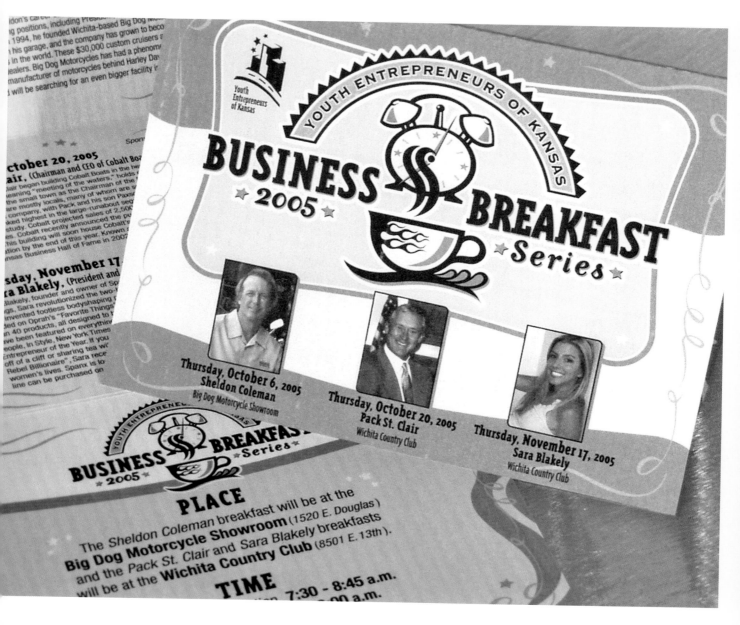

1.

2.

3.

jacobtyler

4.

5.

6.

7.

8.

9.

10.

11.

12.

13.

CONTROLS INTEGRITY

14.

15.

1 - 14
 Design Firm **Jacob Tyler Creative Group**
15
 Design Firm **Laura Coe Design Associates**

1.
 Client Pacific Home Resort Products
 Designer Les Kollegian

2.
 Client L2 Ideas
 Designers Les Kollegian

3.
 Client Underbit Technologies
 Designer Les Kollegian, Yvonne Lay

4.
 Client Jacob Tyler Creative Group
 Designer Les Kollegian

5.
 Client Shee Shee Creative Products
 Designer Les Kollegian

6.
 Client ArmorPoint, Inc.
 Designer Les Kollegian

7.
 Client Entertainment Marketing Association
 Designer Les Kollegian

8.
 Client Loan Genie
 Designer Les Kollegian

9.
 Client Heads for Hire, Inc.
 Designer Les Kollegian

10.
 Client Cocchia Clothing
 Designer Les Kollegian

11.
 Client Coastal Provisions Market
 Designer Les Kollegian

12.
 Client Beachfront Development, Inc.
 Designer Les Kollegian

13.
 Client American Fertility Association
 Designer Les Kollegian

14.
 Client Controls Integrity, Inc.
 Designer Les Kollegian

15.
 Client Cornerstone
 Designers Laura Coe Wright,
 Ryoichi Yotsumoto

1.

2.

3.

4.

5.

6.

7.

1, 2
Design Firm **Laura Coe Design Associates**
3 - 7
Design Firm **Nada Focus, Ltd.**
1.
Client CodeQuest
Designers Laura Coe Wright,
 Ryoichi Yotsumoto, Tracy Castle
2.
Client Helene
Designers Laura Coe Wright, Paul Castaneda
3.
Client VCUP AB
Designer Tautvydas Kaltenis
4.
Client Vilniaus Mazasis teatras
Designer Tautvydas Kaltenis

5.
Client Karaliskas tigras
Designer Tautvydas Kaltenis
6.
Client Via dall Ambra
Designer Tautvydas Kaltenis
7.
Client Labas
Designer Tautvydas Kaltenis
(opposite)
Design Firm **Koch Creative Group**
Client Koch Industries Inc.
Designers Kay Davis, Richard Bachman,
 Dustin Commer, David Hahn,
 Jeff Chilcoat

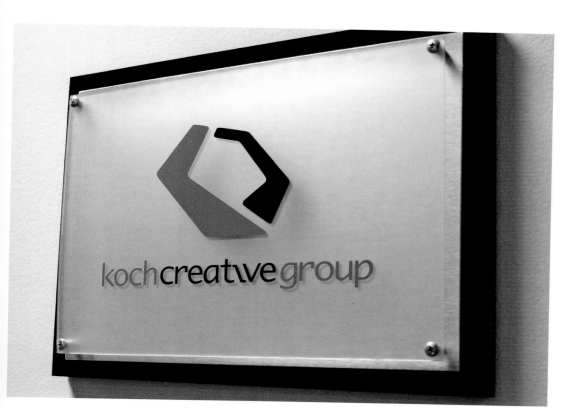

1.

2.

3.

4.

5.

6.

7.

1 - 4
Design Firm **Nada Focus, Ltd.**
5 - 7
Design Firm **TYS Creative, Inc.**
1.
Client Feniksas, Ltd.
Designer Tautvydas Kaltenis
2.
Client Lietuvos socialdemokratü partija
Designer Tautvydas Kaltenis
3.
Client Aukso centras, Ltd.
Designer Tautvydas Kaltenis
4.
Client Cronus, Ltd.
Designer Tautvydas Kaltenis

5, 6.
Client Athletic Press
Designers Tin Yen, Michael Sena
7.
Client Doculogic, Inc.
Designers Tin Yen, Raymond Leung
(opposite)
Design Firm **Koch Creative Group**
Client Youth Entrepreneurs of Kansas
Designers Kay Davis, Dustin Commer

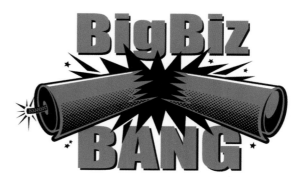

1.

Experience. Partnership. Technology.

2.

3.

4.

5.

6.

7.

8.

9.

10.

11.

12.

THELAB ART+IDEAS

13.

14.

MBM

ESCALATE
LEARNING · TRAINING · EDUCATING

15.

1.

2.

Olivia's Gift
RESEARCH | REHABILITATION | RESPITE

3.

laxmi
consulting™

4.

I'll make it sound good.
Karin Lannon

5.

N TRUE NORTH
Architecture. Construction. Investment.

6.

TM

HeartStar™

7.

1
 Design Firm **Koch Creative Group**
2 - 7
 Design Firm **Square One Design**
1.
 Client Koch Industries Inc.
 Designers Kay Davis, Dustin Commer
2.
 Client Square One Design
 Designer Anna Huddleston
3.
 Client Olivia's Gift
 Designers Anna Huddleston, John Totten
4.
 Client Laxmi Consulting
 Designer Martin Schoenborn

5.
 Client Karin Lannon, copywriter
 Designer Anna Huddleston
6.
 Client True North
 Designer John Totten
7.
 Client HeartStar
 Designer Martin Schoenborn
(opposite)
 Design Firm **Koch Creative Group**
 Client Koch Industries Inc.
 Designers Kay Davis, Dustin Commer

1.

2.

3.

21st Century
**Agriculture
Policy Project**

4.

5.

6.

7.

1, 2
Design Firm **Square One Design**
3 - 7
Design Firm **Matthew Schwartz Design Studio**
1.
Client Viridian Place
Designers Anna Huddleston, John Totten
2.
Client ie3
Designer Lisa Dingman
3.
Client Speedy Fixit
Designers Matthew Schwartz, Stan Grinapol
4.
Client 21st Century Agriculture
 Policy Project
Designer Jennifer Lopardo

5.
Client AKKEN
Designer Jennifer Lopardo
6.
Client Agency Access
Designers Nathan Jones, Matthew Schwartz
7.
Client Radius Marketing
Designers Matthew Schwartz, Nathan Jones
(**opposite**)
Design Firm **Koch Creative Group**
Client Koch Industries Inc.
Designers Kay Davis, Dustin Commer

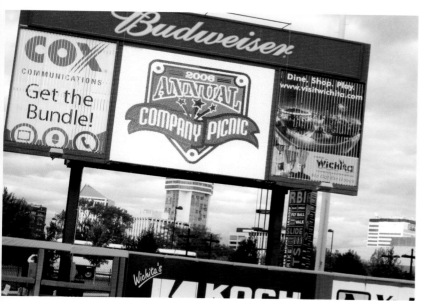

1.

2.

3.

4.

5.

6.

7.

8.

9.

10.

net.**ASSISTANCE**

11.

net.**INVENTORY**

12.

13.

14.

happy.**BIRTHDAY**

15.

1 - 3
Design Firm **Matthew Schwartz Design Studio**
4 - 15
Design Firm **DA2 Strategic Design**

1.
Client Sontag Advisory
Designer Matthew Schwartz

2.
Client Bipartisan Policy Center
Designer Jennifer Lopardo

3.
Client Lotus Public Relations
Designer Matthew Schwartz

4.
Client Città di Ebla
Designers Luca di Filippo, Enrica Corzani

5.
Client Bipres S.p.A.
Designers Luca di Filippo, Enrica Corzani

6.
Client Creditimresa Forli
Designers Luca di Filippo, Enrica Corzani

7.
Client Formart
Designers Luca di Filippo, Enrica Corzani

8.
Client Mii Amo S.r.l.
Designers Luca di Filippo, Enrica Corzani

9.
Client Beesness
Designers Luca di Filippo, Enrica Corzani

10.
Client DA2 Strategic Design
Designers Luca di Filippo, Enrica Corzani

11 - 15.
Client Vem Sistemi S.p.A.
Designers Luca di Filippo, Enrica Corzani

1.

2.

3.

4.

5.

6.

7.

1 - 7
Design Firm **epitype**
1.
Client New Generation Wines
Designers Martin Roach, Harry Ead
2.
Client Insitu Productions
Designer Martin Roach
3.
Client Virtual Wine
Designers Martin Roach, Harry Ead
4.
Client Professional Office Solutions
Designers Martin Roach, Harry Ead
5.
Client ClockSpeed
Designer Martin Roach

6.
Client Action Trust for the Blind,
 Heritage Lottery
Designers Martin Roach, Harry Ead
7.
Client Screen Based Solutions
Designers Martin Roach, Harry Ead
(opposite)
Design Firm **epitype**
Client XOR
Designers Martin Roach, Harry Ead

9.

10.

11.

RICHARD MARTIN /medizintechnik

12.

13.

winCENTIVE
REISEN & EVENTS

14.

15.

1 - 8
Design Firm **Designworks**
9 - 15
Design Firm **revoLUZion advertising + design agency**

1.
Client Acree Creative
Designer Phil Ginsburg
2.
Client Kaizen Websites
Designer Phil Ginsburg
3 - 5.
Client Acree Creative
Designer Phil Ginsburg
6.
Client Inserv Corporation
Designer Phil Ginsburg
7.
Client B&J Auto Transport
Designers Phil Ginsburg, Mike Tardif
8.
Client Shoreline AV
Designer Phil Ginsburg

9.
Client WWR Zerspanungstechnik GmbH
Designer Bernard Luz
10 - 13.
Clients Richard Martin GmbH,
 Gottfried Storz GmbH + Co. KG,
 Karbon GmbH
Designer Bernd Luz
14.
Client winCENTIVE Reisen & Events
Designer Bernd Luz
15.
Client Vega Grieshaber KG
Designer Bernd Luz

1.

2.

3.

4.

5.

mahemedical

6.

7.

1 - 7
Design Firm **revoLUZion advertising + design agency**

1.
Client Gemeinde Streisslingen
Designer Bernd Luz

2.
Client Corina Rues-Benz
Designer Bernd Luz

3.
Client Silke Alber
Designer Bernd Luz

4.
Client Henry N.R.J. Rieker
Designer Bernd Luz

5.
Client MB·Engineering GmbH & Co. KG
Designer Bernd Luz

6.
Client Mahe Medical GmbH
Designer Bernd Luz

7.
Client Mattes Sunstudio
Designer Bernd Luz

(opposite)
Design Firm **Atlantis Visual Graphics**
Client Prince of Peace Lutheran Church
Designer Phil Rogers

Connections

2005 Lutheran Spiritual Outreach Program

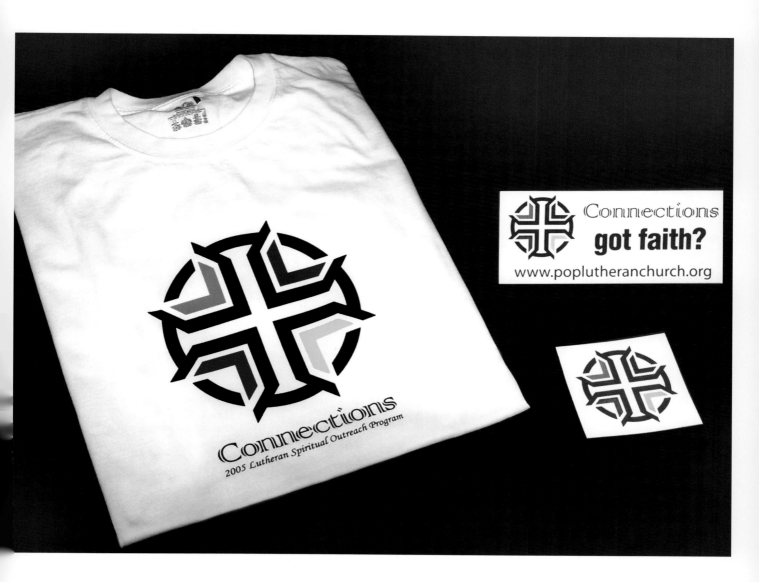

1.

2.

der Familienfriseur

3.

4.

5.

6.

7.

1 - 7
Design Firm **revoLUZion advertising + design agency**
1.
Client Gemeinde Gottmadingen
Designer Bernd Luz
2.
Client Ernst Götz
Designer Bernd Luz
3.
Client Kappler Kooperative
Designer Bernd Luz
4.
Client Inline—Verband Baden—Württemberg
Designer Bernd Luz
5.
Client Konform Kunststoff + Technik GmbH
Designer Bernd Luz

6.
Client Gebrüder Schrott
Designer Bernd Luz
7.
Client Choire of Tuttlingen
Designer Bernd Luz
(opposite)
Design Firm **Atlantis Visual Graphics**
Client Proud Penguin Music
Designer Phil Rogers

1.

2.

3.

4.

5.

6.

7.

8.

9.

10.

11.

13.

14.

15.

1 - 13		
Design Firm	**revoLUZion advertising + design agency**	
14, 15		
Design Firm	**Cyan Solutions Ltd.**	
1.		
Client	Challenge Motors	
Designer	Bernd Luz	
2.		
Client	Kreissparkasse Tuttlingen	
Designer	Bernd Luz	
3.		
Client	Modtek Handels GmbH	
Designer	Bernd Luz	
4.		
Client	Marc Seeh	
Designer	Bernd Luz	
5.		
Client	CleanControlling GmbH	
Designer	Bernd Luz	
6.		
Client	Manuela Häring	
Designer	Bernd Luz	
7.		
Client	Spatech GmbH	
Designer	Bernd Luz	

8.	
Client	Türk + Hillinger Automotive
Designer	Bernard Luz
9.	
Client	Simone Jenter
Designer	Bernd Luz
10.	
Client	Gemeinde Immendingen
Designer	Bernd Luz
11.	
Client	Fliesen Graf
Designer	Bernd Luz
12.	
Client	Kosmotek
Designer	Bernd Luz
13.	
Client	Aquatal
Designer	Bernd Luz
14.	
Client	Ottawa Riverkeeper
Designer	Chantel Secours
15.	
Client	Water Ski and Wakeboard Canada
Designer	Chantel Secours

345

MIND CLINIC
COGNITIVE NEUROLOGY

1.

MELINDA MARTIN
PROFESSIONAL CORPORATION

2.

Hi-RiSE
COMMUNICATIONS

3.

eyes
PROJECT

education youth environment sustainability

4.

EMPEROR
bamboo

5.

cyansolutions
your marketing partner

6.

Bodyworker
Massage · Reflexology

7.

1 - 7
Design Firm **Cyan Solutions Ltd.**
1.
Client Mind Clinic
Designer Jeannine Saylor
2.
Client Melinda Martin
 Professional Corporation
Designer Jeannine Saylor
3.
Client Hi-Rise Communications
Designer Chantal Secours
4.
Client EYES Project
Designer Chantal Secours
5.
Client Emperor Bamboo
Designer Chantal Secours

6.
Client Cyan Solutions Ltd.
Designer Chantel Secours
7.
Client Body Worker
Designer Chantel Secours
(opposite)
Design Firm **Q**
Client Blattgold
Designer Matthias Frey

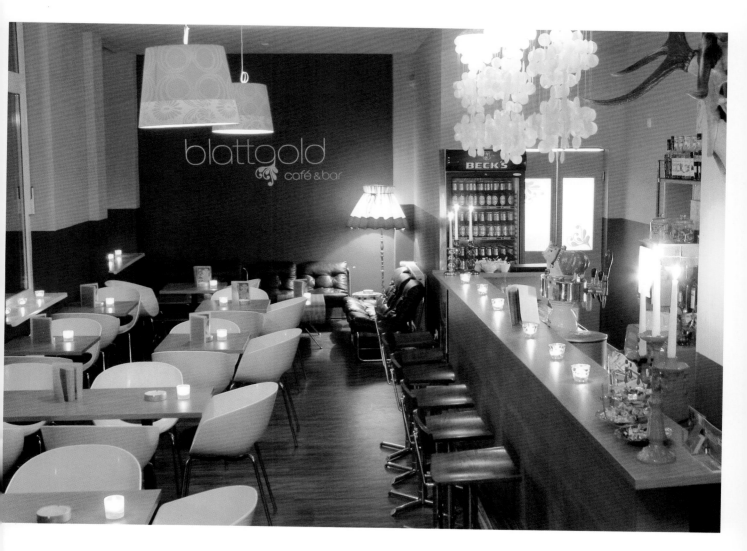

1.

Campbell

2.

équipe immobilière
BERTRAND
real estate team

3.

HessenCh e

4.

PERICON
UNTERNEHMENSBERATUNG

5.

6.

WURDAK
entsorgung

7.

1 - 3
Design Firm **Cyan Solutions Ltd.**
4 - 7
Design Firm **Q**
1.
Client Sevigny Westdal LLP
Designer Chantal Secours
2.
Client Campbell Osler
Designer Chantal Secours
3.
Client Bertrand Real Estate Team
Designer Chantal Secours
4.
Client HessenChemie
Designer Thilo von Debschitz
5.
Client Pericon
Designer Marcel Kummerer

6.
Client Zahnwerkstatt Köln
Designer Matthias Frey
7.
Client Wurdak
Designer Marcel Kummerer
(opposite)
Design Firm **Q**
Client Wemoto
Designer Marcel Kummerer

DESIGN SHIRT SERIES // RD 01.04

© COPYRIGHT 2004 WEMOTO // LOVE YOUR STYLE

1.

2.

3.

4.

5.

6.

7.

8.

1.

2.

3.

4.

5.

6.

7.

8.

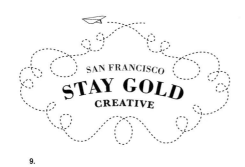

9.

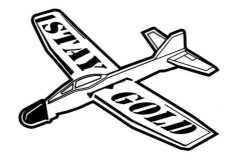

10.

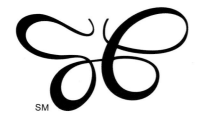

SM

11.

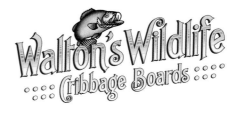

12.

13.

14.

15.

1 - 11
 Design Firm **Stay Gold Creative**
12 - 15
 Design Firm **David Maloney**

1.
 Client Bows and Arrows
 Designer Benjamin Weiner
2.
 Client Huf
 Designer Benjamin Weiner
3.
 Client Mervyns/Oscar De La Hoya
 Clothing
 Designer Benjamin Weiner
4.
 Client Body Tuneup Massage Therapy
 Designer Benjamin Weiner
5.
 Client Avicenna Student Exchange
 Designer Benjamin Weiner
6.
 Client Mash
 Designer Benjamin Weiner

7, 8.
 Client DVS Shoe Co.
 Designer Benjamin Weiner
9, 10.
 Client Stay Gold Creative
 Designer Benjamin Weiner
11.
 Client Simon Consulting
 Designer Benjamin Weiner
12.
 Client Walton's Wildlife
 Designer David Maloney
13.
 Client Semi Studio Systems
 Designer David Maloney
14.
 Client Miley Labs
 Designer David Maloney
15.
 Client Red Circle Media
 Designer David Maloney

1.

2.

3.

4.

5.

6.

7.

1 - 7
Design Firm **CDI Studios**

1.
Client Stone Network
Designers Dan McElhattan III, Ray Perez

2.
Client Strip CD
Designers Tracy Casstevens,
 Dan McElhattan III

3.
Client Vibe
Designer Dan McElhattan III

4.
Client Running Luck Ranch
Designers Victoria Hart,
 Tracy Casstevens

5.
Client Robisons Tae Kwon Do
Designers David Araujo, Dan McElhattan III

6.
Client Pink & Yellow
Designer Dan McElhattan III

7.
Client Nine Courses
Designer Dan McElhattan III
(opposite)
Design Firm **CDI Studios**
Client Oculus
Designers Andrew Herschberger,
 Dan McElhattan III

OCULUS

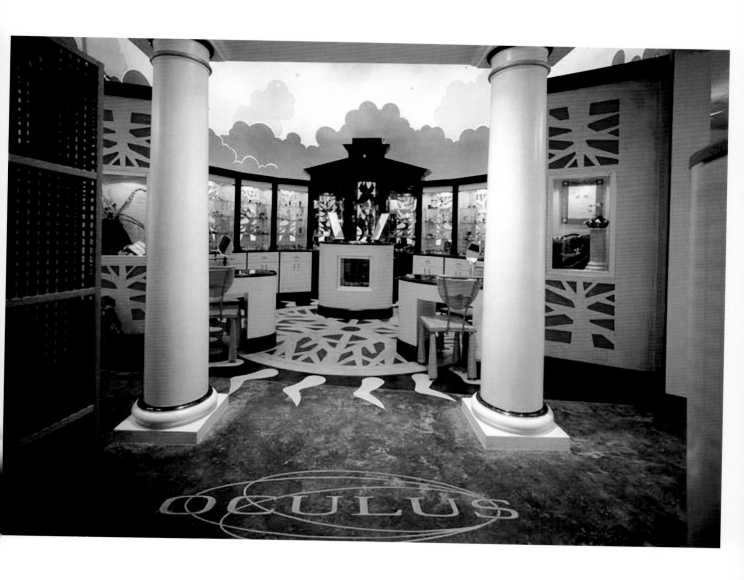

1.

2.

3.

4.

5.

6.

7.

1 - 7
Design Firm **CDI Studios**
1.
Client DownTime
Designer Dan McElhattan III
2.
Client Excellence Logo (DOS)
Designer Aaron Moses
3.
Client Frio
Designer Brian Felgar
4.
Client Ira Ellis Photography
Designers Victoria Hart, Dan McElhattan III,
 Tracy Casstevens
5.
Client Jazzed Cafe
Designer Dan McElhattan III
6.
Client Life Development Church
Designers Victoria Hart,
 Aaron Moses

7.
Client MainStream
Designer Dan McElhattan III
(opposite)
Design Firm **NBC Universal Global Networks**
Client Frame by Frame
Designer Giovanni Staccone

1.

2.

3.

4.

5.

6.

7.

8.

9.

10.

11.

12.

13.

14.

15.

1 - 13
　Design Firm **CDI Studios**
14, 15
　Design Firm **AlMohtaraf Assaudi Ltd.**
1.
　Client　　　Attitude
　Designer　　Dan McElhattan III
2.
　Client　　　AIGA
　Designers　　David Araujo, Dan McElhattan III
3.
　Client　　　SouthWind Financial
　Designers　　Dan McElhattan III, Aaron Moses
4.
　Client　　　CasaMiento
　Designer　　Tracy Casstevens
5.
　Client　　　Rock n' Roll Wine—Amp'd Festival
　Designer　　Dan McElhattan III
6.
　Client　　　Northside Nathan's
　Designer　　Dan McElhattan III
7.
　Client　　　Desert Oral Surgery
　Designers　　Aaron Moses, Dan McElhattan III

8.
　Client　　　Block 16
　Designers　　David Araujo, Dan McElhattan III
9.
　Client　　　AIGA
　Designer　　Brian Felgar
10.
　Client　　　Gasoline Alley
　Designers　　David Araujo, Dan McElhattan III
11.
　Client　　　Rhino Dumps
　Designers　　Dan McElhattan III, Aaron Moses
12.
　Client　　　Chameleon Studios
　Designer　　Dan McElhattan III
13.
　Client　　　Cashmere Photography
　Designer　　Dan McElhattan III
14.
　Client　　　Riyadh Literature Club
　Designer　　Kameel Hawa
15.
　Client　　　Hiwar Gallery
　Designer　　Kameel Hawa

1.

2.

3.

4.

5.

6.

7.

1 - 7
Design Firm **AlMohtaraf Assaudi Ltd.**

1.
Client Malameh Photographers
Designer Kameel Hawa

2.
Client Al Khobar Poultry Company
Designer Greta Khoury

3.
Client Sharaka Co.
Designer Kameel Hawa

4.
Client Ifad Consulting and Training
Designer Yara Khoury

5.
Client Rosewood Hotels and Resorts
Designer Kameel Hawa

6.
Client Al Melhem Group
Designer Maya Rizkallah

7.
Client Royal Commission of Jubail
 and Yunbu
Designer Kameel Hawa
(opposite)
Design Firm **NBC Universal Global**
 Networks Italia
Client Next Media Lab
Designers Next Media Lab

364

1.

2.

3.

CherryFest
CHERRY VALLEY, ARK

4.

WESTERN IMAGE
COMMUNICATIONS, INC.

5.

HOPSCOTCH

HOPSCOTCH *STUDIO*

6.

HARLEMSYMPHO**NY**ORCHESTRA

7.

1 - 3
 Design Firm **AlMohtaraf Assaudi Ltd.**
4, 5
 Design Firm **Chris Corneal**
6, 7
 Design Firm **Hopscotch Studio**
1.
 Client Nema Binshihon
 Designer Kameel Hawa
2.
 Client Sharkawi Contractors
 Designer Yara Khoury
3.
 Client Ministry of Petroleum
 Designer Kameel Hawa
4.
 Client Cherry Fest, Cherry Valley, Arkansas
 Designer Chris Corneal
5.
 Client Western Image Communications, Inc.
 Designer Chris Corneal

6.
 Client Hopscotch Studio
 Designer Dawn M. Hachenski
7.
 Client Harlem Symphony Orchestra
 Designer Dawn M. Hachenski
(opposite)
 Design Firm **FutureBrand Brand Experience**
 Client Riffa Views
 Designers Cheryl Hills, Brendan Oneill,
 Mike Williams, Diego Kolsky

RIFFA VIEWS

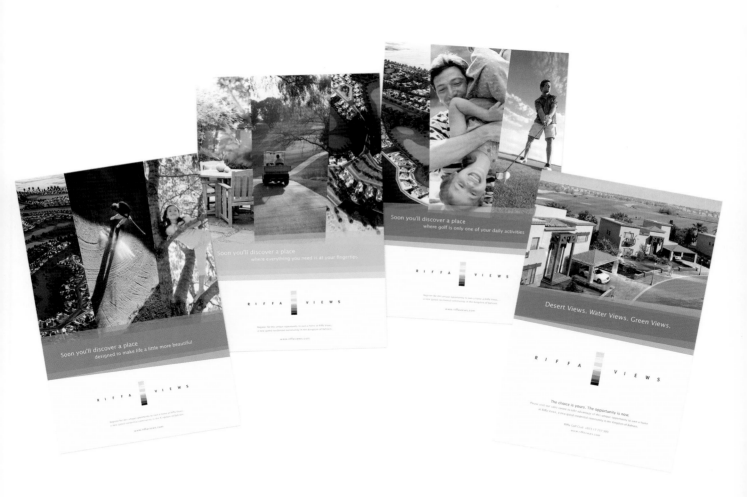

1.

2.

3.

4.

5.

6.

7.

8.

ARTIZANA

9.

LIFECLASS

10.

global ideas stock

11.

Attorneys at Law
Miro Senica in odvetniki

12.

13.

dana

14.

15.

1 - 8		
Design Firm	**Roskelly, Inc.**	
9 - 15		
Design Firm	**Futura DDB d.o.o.**	

1.		
Client	City Ave Development Group	
Designer	Thomas Roskelly	
2.		
Client	Get Moving Walk	
Designer	Thomas Roskelly	
3.		
Client	InterCity Security	
Designer	Thomas Roskelly	
4.		
Client	Guck Boats	
Designer	Thomas Roskelly	
5.		
Client	Associated Community Brokers, Inc.	
Designer	Thomas Roskelly	
6.		
Client	Harris Center for Eating Disorders	
Designer	Thomas Roskelly	
7.		
Client	Apparel123	
Designer	Thomas Roskelly	

8.		
Client	Hudner Oncology Center	
Designer	Thomas Roskelly	
9.		
Client	Artizana	
Designer	Žare Kerin	
10.		
Client	Istrabenz	
Designer	Žare Kerin	
11.		
Client	Open Ad	
Designers	Žare Kerin, Vital Verlić	
12.		
Client	Attorneys at law Miro Senica in odvetniki	
Designer	Žare Kerin	
13.		
Client	Telekom Slovenije	
Designers	Žare Kerin, Marko Vičič	
14.		
Client	Dana	
Designers	Žare Kerin, Marko Vičič	
15.		
Client	SOZ	
Designer	Žare Kerin	

1.

2.

3.

4.

5.

6.

7.

1 - 4
Design Firm **Gustavo Machado Studio**
5 - 7
Design Firm **Mark Deitch & Associates, Inc.**

1.
Client Dating Album
Designer Gustavo Machado

2.
Client Baiao de Dois Filmes
Designer Gustavo Machado

3.
Client Great Videos
Designer Gustavo Machado

4.
Client Innovate 101
Designer Gustavo Machado

5.
Client The Recording Academy
Designer Jessica Bean

6.
Client Mark Deitch & Associates, Inc.
Designer Lisa Clark

7.
Client Trade News International, Inc.
Designer Lisa Clark
(opposite)
Design Firm **FutureBrand Brand Experience**
Client Adnec
Designers Carrie Ruby, Mike Williams,
 Carol Wolf, Alex Sugai

370

1.

2.

3.

4.

5.

6.

7.

1 - 2
Design Firm **Mark Deitch & Associates, Inc.**
3 - 7
Design Firm **LEBOW**

1.
Client Anschutz Entertainment Group
Designers Dvorjac Riemersma, Lisa Clark
2.
Client Mark Deitch & Associates, Inc.
Designers Mark Deitch & Associates, Inc.
3.
Client USA vs Canada Poker Series
Designer Ronnie Lebow
4.
Client IRES
Designer Ronnie Lebow
5.
Client Tiger and Dragon Arts
Designer Ronnie Lebow

6.
Client Granite International Executive Recruitment
Designer Ronnie Lebow
7.
Client Fourth Street Poker Tours
Designer Ronnie Lebow
(opposite)
Design Firm **Heikki Kuula**
Client Yellowmic
Designer Heikki Kuula

1.

2.

3.

4.

5.

6.

7.

8.

9.

10.

Oklahoma City
Tennis Association

11.

12.

13.

VisionQuest
MARKETING

14.

15.

1 - 5
Design Firm **Greenfield/Belser Ltd.**
6 - 15
Design Firm **I.D.ea Factory**

1.
Client College of Law Practice
 Management
Designer Shikha Savdas

2.
Client Choate Hall & Stewart LLP
Designer Burkey Belser

3.
Client Epiq Systems, Inc.
Designer Aaron Thornburgh

4.
Client Fox Rothschild LLP
Designer Margo Howard

5.
Client Peck Shaffer & Williams LLP
Designer Burkey Belser, Shikha Savdas

6.
Client Milestones
Designer D. Brian Ward

7.
Client Haiyen Trading
Designer D. Brian Ward

8.
Client Red-E 2 Wear Apparel
Designer D. Brian Ward

9.
Client I.D.ea Factory
Designer D. Brian Ward

10.
Client Davis Evans Pianos
Designer D. Brian Ward

11.
Client Oklahoma City Tennis Assoc.
Designer D. Brian Ward

12.
Client Nocturnal Design
Designer D. Brian Ward

13.
Client Thou Art Apparel
Designer D. Brian Ward

14.
Client Vision Quest Marketing
Designer D. Brian Ward

15.
Client Wynnewood High School
Designer D. Brian Ward

1.

2.

3.

4.

5.

6.

7.

1
 Design Firm **I.D.ea Factory**
2 - 4
 Design Firm **Seran Design**
5
 Design Firm **DirectLine Productions**
6, 7
 Design Firm **McMillian Design**
1.
 Client Mind's Eye Apparel
 Designer D. Brian Ward
2.
 Client Rich Cleaners
 Designer Sang Yoon
3.
 Client College of Visual
 and Performing Arts
 James Madison University
 Designer Sang Yoon
4.
 Client Furious Flower Poetry Center
 Designer Sang Yoon

5.
 Client Burton Neil & Associates
 Designer Steven Strohm
6.
 Client Artisan Wine Company
 Designers William McMillian
7.
 Client Big City Marketing
 Designers William McMillian
(opposite)
 Design Firm **DirectLine Productions**
 Client Tri-State Bird Rescue and Research
 Designer Steven Strohm

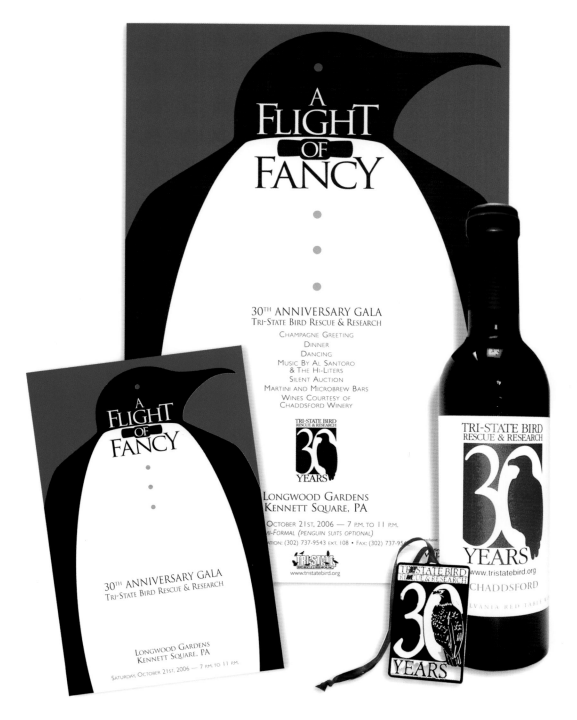

1.

2.

3.

4.

5.

6.

7.

1 - 4
 Design Firm **Curiosity Group**
5 - 7
 Design Firm **Minds On, Inc.**
1, 2.
 Client MacForce
 Designer Alberto Cerriteño
3, 4.
 Client Curiosity Group
 Designer Alberto Cerriteño
5.
 Client Intellinetics
 Designers Tom Augustine, Randy James,
 Doug Stitt
6.
 Client AD Giants
 Designers Tom Augustine, Randy James,
 Doug Stitt

7.
 Client File Preserver
 Designers Tom Augustine, Randy James,
 Doug Stitt
(opposite)
 Design Firm **FutureBrand Brand Experience**
 Client Bahrain Bay
 Designers Cheryl Hills, Diego Kolsky

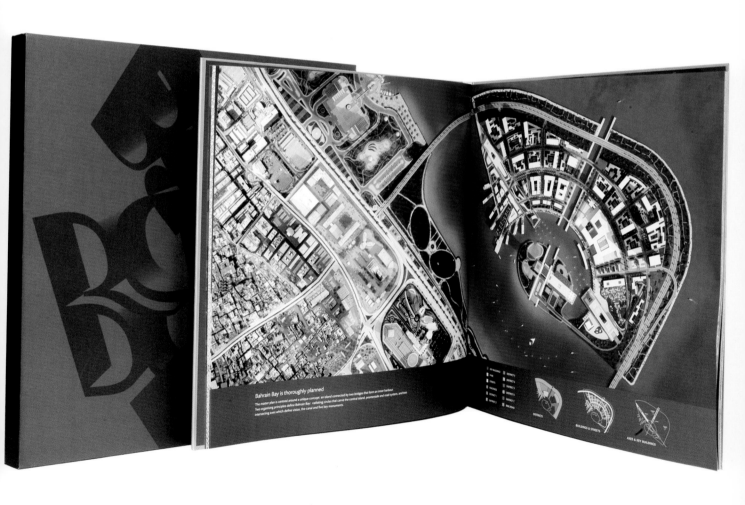

Bahrain Bay is thoroughly planned

Index